# FAME US

ARSENAL
PULP PRESS

# FAME US

CELEBRITY IMPERSONATORS AND THE CULT(URE) OF FAME

BRIAN HOWELL

ARSENAL PULP PRESS
Suite 200, 341 Water Street
Vancouver, BC
Canada V6B 1B8
*arsenalpulp.com*

The publisher gratefully acknowledges the support of the Canada Council for the Arts and the British Co-lumbia Arts Council for its publishing program, and the Government of Canada through the Book Publishing Industry Development Program and the Government of British Columbia through the Book Publishing Tax Credit Program for its publishing activities.

Cover design by Brian Howell
Text design by Shyla Seller

Printed and bound in Canada

Library and Archives Canada Cataloguing in Publication:
Howell, Brian, 1966-
     Fame us : celebrity impersonators and the cult(ure) of fame / photographs by Brian Howell ; foreword by Stephen Osborne ; introduction by Norbert Ruebsaat.

ISBN 978-1-55152-228-9

     1. Celebrity impersonators—Biography. 2. Celebrity impersonators—Portraits. 3. Entertainers—Biography. 4. Entertainers—Portraits. 5. Fame—Social aspects. I. Title.
PN2071.I47H68 2007 791.092'2 C2007-904468-9

*For Charlie and Lucy.*

# CONTENTS

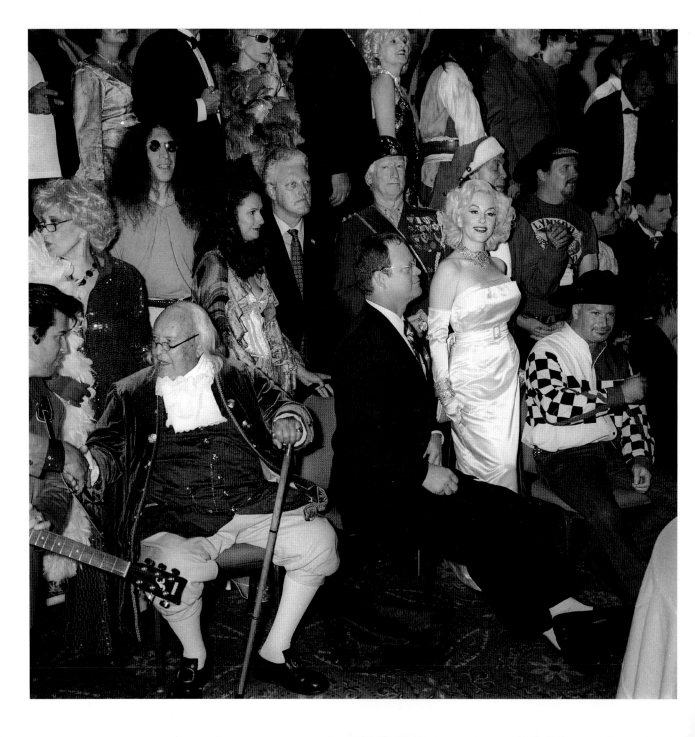

# SEEN BY MANY: The Celebrity Image

Norbert Ruebsaat

1.

Celebrity, as we know it today, was created by modern mass media. It began with photography in the early nineteenth century when, for the first time in history, masses of people could regard images of themselves in something other than a mirror. They could regard images of others too, and of things and places they had never seen before, and a new imaginative space opened in which society could compose itself and individuals could locate themselves in a new public world.

There were famous people before photography, but these famous people were seldom seen, and they were not seen by many. Their fame derived from story and legend, orally-transmitted tales and accounts of their deeds; they were not visual creations. Average people saw few images, and those they did see were religious and iconic, never realistic. They saw no pictures of themselves. So when early daguerreotype photographers set up shop and showed them exact replicas not only of themselves but also their loved ones and well-known strangers, they were astonished, sometimes even frightened.

Low-cost daguerreotype photography became popular immediately, and in 1839, Paris newspapers diagnosed a new disease called *daguerreotypomania*. By 1840, daguerreotype studios in Europe and the United States were producing unique, detailed likenesses that could be taken home in hinged leather cases, and a new class

gazed in amazement at its own image in these "mirrors with a memory." French painter and photographer Adolphe Disdéri in 1854 invented the *carte-de-visite*, a form of photographic calling card, which soon became a new rage. It created an instant market for both celebrity and personal photographs in France and England. Cartes, as they were known, were both traded and collected. They were the first mass photographic medium to generate celebrity value in the modern sense, and their mix of images linked royalty with commoners, actors with audiences, old society with new. Fame suddenly seemed available to all.

When film was invented at the end of the nineteenth century, the imaginative space opened by photography broadened. People imagined themselves not only as images but also as stories, and stories told in film images made one a character. Previous storytelling technologies—first word-of-mouth, then writing and printing—were aural mechanisms, or textual versions of imagined speech. But now, one could "see" oneself, photographically reproduced and realistically portrayed, in the story: one was character, a star in a new narrative universe.

Film as an entertainment medium involving characters began in the early twentieth century. In America, Hollywood studios capitalized on the new form of imaginative storytelling by creating the movie star, a character who plays a succession of roles on public screens, and in the early 1900s, he/she became the vehicle through which audiences identified and insinuated themselves into the new medium. They imagined along with the celluloid text, creating roles also for themselves as "stars," roles which helped them live in a complicated new world. Silent film actress Florence Lawrence, arguably the world's first "movie star," was known as "The Girl of a Thousand Faces," and in addition to starring in 270 movies, she established the Hollywood tradition of multiple marriages (in her case, three). Mary Pickford

was "America's Sweetheart," "Little Mary," and "the girl with the curls," and as the star and cofounder of United Artists was one of filmdom's great pioneers. Known world-wide as a result of moving images, she is considered a watershed figure in the history of modern celebrity.

Movie stars became templates for personal action, reflection, and imagined identity. They were both real and celestial, normal people rendered glamorous by media; people from everyday life who had been discovered ("touched") by fame: in real life, Marilyn Monroe was Norma Jean Mortenson, John Wayne was Marion Michael Morrison, Rock Hudson was Leroy Harold Scherer, Jr. As a result, "average" people saw themselves personally reflected in these newly famous movie actors. The most successful stars could be you or me. They were a new kind of "Us."

In order to control their public personae and capitalize on a new commodity, Hollywood film studios worked with agents and managers to construct both on-screen and off-screen images for the early stars. They created public "personalities" that moved in both real and fictional time/space, and brutal tactics were often employed to maintain them: Judy Garland's legendary drug problems began when MGM fed her uppers to maintain her perky persona and non-stop work schedule; Rock Hudson's marriage to a woman was arranged in order to fend off rumors of his homosexuality. As actors became famous, packs of tabloid reporters and photographers began chasing them around to gather images and gossip about their "private" lives. These early paparazzi knew that the stars' fans, which is what members of the movie audience came to be called, were more interested in these "real" stories and images than they were in the fictional screen ones, whether they were happy photo-ops of Marilyn Monroe on her honeymoons or tales of scandal, like Elizabeth Taylor's affair with Eddie Fisher while the latter was still married to

Debbie Reynolds. An entire tabloid and magazine news industry—combining the old technology of print with the new technology of high-speed snapshot photography and halftone printing—developed around the star-as-image; one could get to know stars personally as tabloid gossip items, and publicly, as movie idols, all in the same breath. This dual experience fostered a new kind of infectious pleasure and inspired a passion for celebrity minutiae; it facilitated deep imaginative play between real and fictional realms and became an abiding social pleasure-seeking habit.

Celebrity proper is born in the space between star-as-real-person and star-as-entertainment phenomenon. Celebrity means being celebrated, and it involves being seen by many. It also requires being seen in many places and being continually re-imagined. Once fans got to know their star in both real life and the movies, the star's power became detached from specific media. The star's persona developed in new combinations to become an independent power, a force which could move through many levels that encompassed both real life and all mediated forms of life. However, the difference between the two is erased by celebrity's power: celebrity becomes an agency separate from any traditional conception of culture and art, and while moving through any culture, reinvents it. An early example of this mobility is Grace Kelly. Working with renowned directors and leading men (a number of whom she bedded), she starred in eleven movies, received an Oscar for one of them, and at the height of her career left Hollywood to marry Prince Rainier III of Monaco, which transformed her into Her Serene Highness the Princess of Monaco. The marriage of Prince and Movie Star was fodder for non-stop tabloid gossip and speculation, calculated and choreographed public appearances, and late-night television reruns. Princess Grace, as she became known, appeared on stamps, royal coats-of-arms, and money, and was the first entertainment star to achieve "real-life celebrity."

2.

When television began broadcasting in the late 1940s, the separate worlds of the tabloid press and the film industry joined forces again. Television, with its ability to link real life with fictionalized life, real time with mediated time, real people with "live" performers—and, most importantly, the private world of the home with the public world of politics and economics—was a natural habitat for celebrity power. The movie star could reveal her/his real behind-the-scenes self to the television talk show host, who was a celebrity in his/her own right, and after watching their chat the viewer could see the star in a movie. For the TV viewer, the imaginative play between fiction and reality reached new heights. Television publicity and star-mongering promoted further magazine and tabloid growth, and the self-generating and regenerating multi-mediation that is the "celebrity machine" clicked into gear.

Once celebrity power had become an independent agency, detaching itself from specific media as well as from real life, it became available to other kinds of public individuals. Sports stars and music stars had, even before the birth of the movie star, a quasi-independent celebrity existence, because their disciplines involved strict, organized routines, but now they could step fully into the new limelight as multi-tasking celebrities detached from these routines. Early examples of music stars who crossed over into film and became multi-platform celebrities are Bing Crosby, Dean Martin, and Frank Sinatra, with Elvis Presley following a generation later. Crosby starred in music halls, on radio, in film, and on TV; Martin began his career as a boxer, then became a crooner, comedian, and movie star; and Sinatra was America's first teenage idol and heartthrob-cum-movie-star-cum-independent-celebrity and precursor to Elvis, who would be regarded as The King. The phenom-enon continues to this day, with musicians-turned-"actors" like Eminem, Beyoncé,

Justin Timberlake, and Madonna. All these performers expertly negotiated star power that was gained in one idiom and medium into currency that flowed into others; along with their agents, managers, and fans, they laid the groundwork for the modern celebrity brand as commodity.

Once power is in the air, politicians soon make their appearance. Political communication had for decades focused on public oration (Abraham Lincoln gave six-hour public speeches, just as Fidel Castro did until recently), and then turned to radio (Hitler, Churchill, FDR), but the politician-as-celebrity came into existence in the television age. Its first great North American representatives were John F. Kennedy, the first president elected in no small part due to television, given his youth and good looks, and Canadian prime minister Pierre Trudeau, whose dynamic persona resulted in "Trudeaumania." The latter-day apogee of is, of course, Bill Clinton, who came into his own right when he played the saxophone on Arsenio Hall's television talk show during his first presidential campaign. Kennedy was a master at using media to his advantage, and his beautiful almost blue-blooded wife Jacqueline shared the talent. America was mesmerized by Jacqueline's beauty and class, with millions watching her on television when she gave them a tour of the White House. Trudeau, of course, also used the acquisition of a wife to great televisual advantage, and is the first Canadian prime minister to found a potential lineage. The politician-as-star and then as a celebrity, ushers in a new kind of polity. Political procedures become show business protocols, advertising and marketing practices take over election campaigns, and democracy becomes visual, a matter of correct branding and brand management.

The promotion of branded products started as the modern celebrity culture came of age. In fact, the branding of goods has much in common with the "branding" of

celebrities; power is derived from a high recognition factor. Both are free-floating signifiers (as scholars call them) of desire; they capture the audience's attention by their "openness," and their ability to generate multiple meanings or stories. If products are the celebrities of the economy—and if movie stars, music and sports stars, then politicians turn to this source of status and power—we can understand that economics has *become* culture: the market is now the source of all meanings as well as all goods. Branding erases the separation between economic and the cultural realms, between marketing and communication. In the "new economy," as it is called today, the brand is king, whether person or product. Celebrity moves in from either end, and we—the audience, the fans, the celebrity-watchers—become consumers of re-imaged, re-imagined, and reconstructed culture.

A few other celebrity types need to be mentioned here. Fashion models, who were initially understood to be display vehicles for clothes and accessories, increasingly, as a result of TV advertising and new developments in magazine photography, became stars in their own right. When they discovered this, they, like the movie stars, bargained this star power into celebrity positioning. They appeared on talk shows, made guest appearances in soaps and sitcoms, and soon, especially when they began to make "public appearances" as defenders of causes, they fully entered the realm of the celebrity. They became supermodels, a status which Cindy Crawford, one of the first, likened to being The Real Thing. (Just like Coca-Cola, one of the products she hawked.) It seems appropriate that as models became celebrities, they too were prey to scandal and intrigue, as evidenced by our fascination with Naomi Campbell's various run-ins with the law for throwing cellphones at her maids, or Kate Moss's infamous cocaine video.

3.

The debut of *The Real World* on MTV in 1992 was the advent of the phenomenon known as reality television, which was in fact a combination of different television genres. Its most influential antecedent was the game show, a cheap format developed in the 1950s to sell products to housewives. Its second inspiration was soap opera, in which private lives and conflicts were explored by well-coiffed wanna-be TV stars. Other sources of inspiration were real-life travel documentaries, news "backgrounders," talk shows, and live sports broadcasts. The reality format fused the different viewing habits cultivated by the earlier formats. Like the game shows, it was cheap (you didn't have to pay actors) and, again like the game shows, it featured normal people (i.e. like you or me) as its stars. And, like the game shows, reality shows offered prizes, their biggest prize being not products or money, but stardom. The genius of the reality genre (aside from its cost-saving aspect) is that it offered everyday people, even viewers themselves, the chance to be seen by many while doing things previously done only by movie or music or sport or model stars—by being, in fact, themselves.

Reality shows, from *Survivor* to *American Idol*, *America's Top Model* to *The Amazing Race*, have been the dominant television genre in recent years. They have spawned multiple offshoots and variations, been internationalized, and turned many participants into stars. These participants did not always become full-fledged celebrities (this being television, not the movies), but they established a sense of identity, a "this could be you, and at times even *is* you" kind of intelligence that embedded itself in the cultural psyche. Everyone is now, or, as we have always secretly known, could be a potential star and a possible celebrity. You don't even have to be good; you can be stupid or awful. Whatever the case, you can be yourself

in every way, and the music, editing, dodgy "auditioning" and on-location direction involved in these shows (not to mention the occasional mean-spiritedness) notwithstanding, you too can be accepted, and seen by many, in many places.

Reality television's popularity has influenced the news media as well. "Soft" stories once given a cursory thirty seconds at the end of a broadcast may now be the lead-off item, a shift in priorities that can be traced to the O.J. Simpson murder trial in 1994 and the seminal moment when O.J. was "on the run" through the streets of Los Angeles, with television crews capturing it all live. As a result, scandals involving celebrities like high-profile divorces, battles with drugs and alcohol, or other falls from grace, now make daily appearances in our lives, whether through *The National Enquirer* or CNN. The daily live coverage of the Clinton-Lewinsky hearings held America spellbound, and when Princess Diana's car crashed in Paris almost in front of our eyes, the world wept at a tragedy staged, some claimed, by paparazzi.

These daily, real-time news stories, played out in the "real life" time of the television schedule, garnered huge ratings, as do reality shows. The difference between them is that in the former, the participants are already famous, and in the latter they are not—at least, not yet. Whether "real" or "reality," however, when you watch and imagine yourself "in" the show, you feeling the power of celebrity. You love your celebrities when they rise, because they are true and beautiful, and you rejoice when they fall because you know on some level that, of course, that they are also fake. You accede, in either case and in both formats, to a simple fact: that fame is reality, it exists, and it is available to all.

4.

In the age of the Internet, a.k.a. "the new information age," the average-person-as-celebrity trope first introduced by reality television comes to the fore, and organized mass media plays its final card. In the new and evolving world of digital communication, the old division between media producers and media consumers, senders and receivers, stars and fans, and celebrities and followers breaks down. With a computer and an Internet connection, anyone can send and receive mass-mediated stories as pictures, text, and sound. If we leave aside the fact that a vast number of people in the world do not own computers (and will therefore never achieve celebrity status), we can say that with the means of (cultural) production now in hand we have achieved if not the real, then (of all things) at least a semiotic version of Karl Marx's post-revolutionary classless society. In cyberspace one is, each in one's own small way, a captain of industry. MySpace, YouTube, Friendster, Facebook, the Blogosphere, and Webcam-live-streaming offer open vistas for the canny entrepreneur that the old-time industry barons could not have imagined as they stared out office picture windows at their vast industrial holdings. One can be a kind of personal star in the new cybereconomy, a private/public celebrity, a diva or monster of the Internet; a director, author, and editor, all at the same time. Here, it is possible to be famous—a "someone," in the private/public world of the computer screen—and be oneself *at the same time*. And one can be seen, in both modes, by many and in many places. Call them venues. Call them platforms. Call them "me": I, Celeb.

The Internet has also increased tremendously the thirst for and availability of celebrity gossip and speculation. The advent of celebrity bloggers like Perez Hilton and paparazzi-driven sites like TMZ and X17, which feature celebrity stories and

photographs both scandalous (drugs! rehab! DUI!) and mundane (stars pumping gas or shopping for groceries), are updated hourly, creating not only a desire but an expectation of celebrity-watching, every day, all day. They fully erase the old distinctions between news, entertainment, and advertising. The instantaneousness of celebrity "news-and-information" and its narrative immediacy—it's not on your TV, it's on your private laptop, your cell phone, your Blackberry, your iPhone, your available "favorites"—makes celebrity so accessible that people experience fandom as a kind of euphoria or addiction. You are forced to keep up, as the laborer's body needed to keep up with the conveyor belt in industrial times. MySpaces, Second Lives, and their clones, working in tandem with the celebrity consumption sites, extend the exhilaration of self-production, self-generation, self-duplication, and multi-mediating to infinity, and public celebrity-as-power manifests itself in the entirely personal sphere. Cruising "cyberspace" becomes daily production-and-consumption work and the idea of the "self" morphs into cyborg identities.

German philosopher and media scholar Walter Benjamin told us in the 1930s that when a work of art is mechanically reproduced, it loses its "aura." The aura is the inexplicable something, the genius or spirit, which hovers like light around a work of art and signals its authenticity and uniqueness. Benjamin wrote that the eradication of this aura moved the work of art from the realm of aesthetics into the world of politics and economics, and that when art was mechanically reproduced, the star of the show became the producer, not the artist. (And certainly not the subject.)

With computer media and Internet connections, we can think of ourselves in this light as producers, as cybered Captains of Industry. We can produce and send and receive and "be interactive" in mechanically reproduced "hyperreal" environ-

ments, inhabit Second Lives or dot-com bubbles of our own making, and we can be star, producer, real person, fake person, dog, and so on, in our own personal reality show. We have, at our fingertips, celebrity status and power. This is no small matter. If you were a Marxist, you might well agree that we have manufactured the elixir desired by all revolutionaries: freedom—in our case, of choice, in the form of available technologies. Captains of industry—who might in fact be our Ur-celebrities, the secretive, nineteenth-century ones Marx wrote about, who hid their images behind their money and their temples—found their power in their invisibility, not their visibility. In cyberspace, we can have both, or neither. We have the choice to appear or not. We can be signifier *and* signified, as semioticians describe this state, and this is an exhilarating elixir.

It is interesting to note here that some "real" captains of the old commodity or service economy are also now coming out of the vault (or the castle closet) and re-exposing themselves as celebrities in their own right. Witness Donald Trump, who, as producer, host, and star of *The Apprentice,* ran his company (it appeared) as a reality TV show in which he fired and hired employees on the air. Witness also Conrad Black, Canada's grimly wealthy celebrity copy of the old-time media barons, Randolph Hearst and Joseph Pulitzer. Talk about celebrity hubris—he parlayed his media barony into a real-life one, and the fact that he will go to prison for embezzlement and racketeering is poetic, and perhaps appropriate in the modern celebrity age.

And then there's Paris Hilton—who people say is famous for doing nothing while knowing at the same time that she is famous for being rich, "beautiful," scion of a hotel empire, and "hot." Her sex tape scandal and recent imprisonment, which in earlier decades may have been career-ending, have in the era of the celebrity only

enhanced her legend. And Bill Clinton who, after surviving and apologizing (as celebrities are prone to do these days on TV talk contrition sites) for the Lewinsky scandal, picked up his drawers and regained his celebrity savoir faire and, moving across multiple platforms, now collects millions on the public speech circuit. Finally, there's the arch celebrity himself, Arnold "the Terminator" Schwarzenegger. He began celebrity life as an Austrian immigrant bodybuilder, became Mr. Universe, transformed himself into Hollywood action star and boy's action figure, and then again as Governor of California. When he came to Vancouver, BC in June 2007, local politicians and media settled in swarms around his botoxed greatness for photo ops. The politicians looked awkward next to Arni, they didn't know what kind of faces to make, their bodies looked small (how should they pose?), and when they shook hands with the star of *True Lies*, it was as if they were entering a force field.

Once the old relationship between senders and receivers of messages breaks down, there are no more speakers and listeners as there were in the heroic oral ages, thus the meaning and structure of communication shifts. Media scholars like Marshall McLuhan have noted that this process began with the invention of print, the West's first mass medium, whereby communication became "internalized." Silent. One communicated while reading with oneself. An audience of one could be, in this way, both star and fan: one's own personal secret celebrity. With electronic narrative, such as photo, film, TV, and Internet, this interiorized world became exteriorized, vocal, filled with sounds and images so real that they become hyperreal. Electronic media reimagined the world, and in so doing, recreated it. It was theory and praxis, to quote Marx again (who was once a celebrity but had a big fall), and the world it has produced can no longer be compared with the world it colonized and eventually deleted.

As images, as stars, as celebs—of our own making and for our own consumption—we are no longer interested in the relationship between the representation and the represented, between who we "are" and who we "want to be" (or not be). The aura of that kind of decision-making is gone. Jean Baudrillard, the French philosopher and sociologist, wrote that we now live in a post-media age, the age of the simulacrum. In this age, every thing, person, place, representation, and copy is a simulation of something else. Nothing, in other words, is real in the old sense. Baudrillard, who died in March 2007, wrote that "dying is pointless," and that he would not die until death could be represented, which it cannot be (although many have tried). In the age of the simulacrum, he wrote, one "has to know how to disappear." After an American road trip, he wrote that the US was paradise, that it was utopia, that it was a successful revolution. "But is this really what an achieved utopia looks like? Is this a successful revolution?" he asked his reader(s). "Yes indeed!" was his rhetorical answer. "What do you expect a 'successful revolution' to look like? It is paradise. Santa Barbara is a paradise; Disneyland is a paradise; the US is a paradise. Paradise is just paradise. Mournful, monotonous, and superficial though it may be, it is paradise."

In a cybernetic universe where the self and its world, as imagined by the old reality, has become simulacrum—in which the self-as-celebrity has grown into an independent abstract force that feeds on and feeds power back to the media and in doing so produces, reproduces, and re-reproduces *ad infinitum*, simulations of experience at hyper speeds—celebrity is what we have. Maybe we are attempting to regain—via replication, duplication, and simulation—technology's dream, the very aura Walter Benjamin claimed was destroyed by these practices. Or perhaps we are playful avatars, creating and heeding, with the touch of a finger, all the commands that our imaginations can conjure. We cling to it, this New Reality, which is already

disappearing as we speak or surf, because it's exciting, exhilarating, scary, sacred, transcendental, banal, otherworldly, terrifying, unreal, and awesome all at the same time. It is us. Hard to imagine. In the early days of photography, people who saw their own image reproduced for the first time by the action of light on chemically treated paper or glass had similar emotions. Some believed that photographs stole their souls, or that their likenesses were pure evil. Others experienced spiritual ecstasy, personal transcendence, love, even, in the presence of their replicas. Some people experienced all these things at the same time. The photograph has traveled a long way. Now, in this book, it is back.

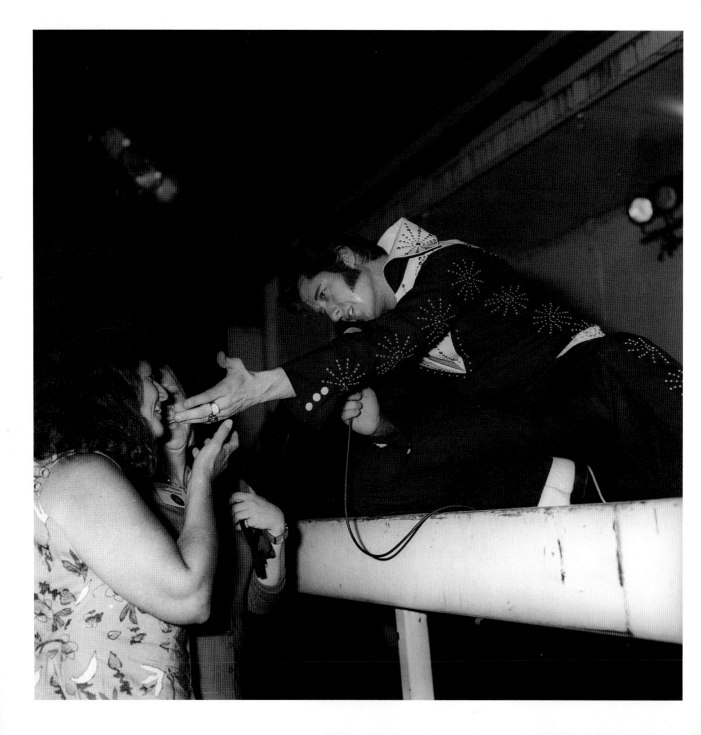

# SIMULATING PEOPLE

Stephen Osborne

When Brian Howell attended his first Celebrity Impersonators Convention at the Imperial Palace Hotel in Las Vegas, he asked a Roseanne Barr impersonator to pose for him, and she told him he looked exactly like her brother-in-law. Then she asked him to pose for *her* so that she could show his picture to her family back home. Many celebrity impersonators (or "tribute artists" as they are also called) are drawn into their impersonating careers from the replication of just such a moment: when other people tell them that they look like someone famous. The brother-in-law in Howell's encounter was not famous, as it turned out, so the moment of recognition remained for Howell a mere simulacrum of the "real" thing.

Howell's first glimpse into the impersonating world came at a lively Sunday gospel meeting in southern British Columbia led by an Elvis impersonator who told him that his Elvis costume had given new meaning to his life. Howell had been documenting a small-time pro-wrestling circuit in the Pacific Northwest, an undertaking that led him to develop a formal, almost old-fashioned style of photography that lends itself well to the display of extravagant performance and bizarre spectacle. In wrestling, appearance is everything; much the same thing is true of celebrity impersonation, which combines physical likeness with gestures more or less expertly performed. Looking at an impersonator, one doesn't see the two identities at the same time; instead, your perception flickers between them, and this ambiguity challenges our notion of authenticity, and of celebrity. The spectacle offered by the impersonator is complicated so to speak by the absence of the object in the presence of the subject. When we confront the image of Cher in the body of an imper-

sonator, are we confronting anything different than the image of Cher elsewhere in the culture—even if the person impersonating "Cher" is Cher herself? What does it mean to shake hands with "Jack Nicholson," whose being as a celebrity is nothing more than the impersonation that he makes of the person he looks like? The work of the celebrity is to look like the celebrity that the public expects them to look like—in short, to impersonate themselves. Elizabeth Taylor's great work is in maintaining her look, in charging her image on screen, on stage, on paper—with *presence*—just as it was for Marilyn.

The impersonating world is a hall of mirrors through which Brian Howell has sought out myriad reflections of celebrity at every level, from the neighborhood gospel show, to community centers catered by Lions Clubs, and finally to the heart of it along the Las Vegas Strip, to which Howell returns again and again as he pursues these refracted images which stand as allusions to unattainable celebrity.

The Las Vegas Strip is itself an accomplished impersonator of celebrity places (among its topographical features are structures resembling giant photographs of the Manhattan skyline, the Eiffel Tower, the Pyramid at Luxor, as well as miscellaneous bits of Paris and Venice) and it seems almost to be expected that shades of famous people dead or alive might be walking its streets, or that several versions of Shania Twain or Dean Martin might appear at the same time in a hotel lobby, along with renderings of Marilyn Monroe, Elizabeth Taylor, Saddam Hussein, Sammy Davis Jr., Tom Cruise, Tina Turner, Ozzy Osbourne, Rodney Dangerfield—a list that by implication grows indefinitely. On a visit in 2004 Howell recorded the real-life exchange of wedding vows between a Shania Twain and an Arnold Schwarzenegger, both in character, before a non-impersonating priest at the Imperial Palace Hotel. (Like so many celebrity marriages, this one did not work out.) Later he got into an

elevator with an Oprah Winfrey impersonator who, when he congratulated her on her fine impersonation, turned out to *be* Oprah Winfrey, impersonating herself. At the heart of the impersonating world lies the casino of the Imperial Palace (home of the Celebrity Impersonators Convention), whose dealers are themselves celebrity impersonators, and where you can be paid off at a Blackjack table by a living replica of Michael Jackson.

The rise of celebrity culture corresponds to the rise of the entertainment industry and the mass media, which in turn arose from the development of photography in the nineteenth century. Celebrity impersonators are a phenomenon of the late twentieth century, and have been proliferating ever since the death of Elvis Presley, who continues to inspire a vast following of impersonators of all degrees of ability. Until the death of Elvis, an impersonator was a deceiver, a con-man or fraud artist (as the newspapers like to say), or a character in a drama; but now impersonators are legitimate entertainers in their own right.

Photography is the sole vehicle of celebrity: without the image (on the page or on TV, movie, and computer screens) to refer to, there is nothing to validate the celebrity's celebrity status ("My greatest lover is the camera." —Greta Garbo). Only in photography is celebrity perfectly expressed: photography alone authorizes celebrity, allows it, confirms it. The impersonator too emerges from photography: enabled, informed, by the celebrity image.

The celebrity world is informed by an endless doubling of images indexed through magazine pages, gossip blogs, and movie and television screens; it takes its life from a supply of images that must be renewed daily or even hourly, hence the demand for the industrial strength photography of the paparazzi. ("A picture of

a celebrity is like hard currency. Good anywhere in the world," says a paparazzo in the documentary film *Blast 'em*.) In the sea of images that defines public space, we find the same faces repeated again and again in glimpse after glimpse, snapshot after snapshot. At the high-art end of celebrity photography, we are given the elaborate productions of Annie Leibowitz, who solves the problem of the ubiquity of celebrity, its essential sameness, by adding patina to her subjects, by piling more appearance upon appearance to the celebrity body—mud, paint, outrageous clothing, bizarre settings, etc.—in order to disguise (and thereby to reveal) the emptiness at the heart of celebrity, where one fears there might be nothing to photograph.

Howell's impersonator photography is the opposite of celebrity photography. The impersonating world is not a fleeting one; it strives toward the monumental: time is slowed down, if not stopped outright. In the impersonating world, Bogart persists in his sardonic ways, Bacall remains forever sultry. The impersonator has already done what the camera does, which is to preserve the appearance of a moment: Howell's response is to scrutinize that moment; he takes his time and by doing so gives us time to take a good look. We linger with these images in the enduring moment as enacted by the impersonator posing for the camera.

Howell remains attentive to his subjects; he does not assault them with the lens, nor does he surprise them, but the nature of his subject remains elusive. We can say that celebrity is his subject, and we can say equally that the mask is the subject of these photographs. How well the mask invokes the absent celebrity is one way to measure the "success" of the impersonation, but it does not measure the emotional investment, the existential weirdness that impersonation implies and that Howell's photographs display.

What we cannot help seeing again and again in these pages, which is perhaps why the photographs are ponderable in a way that straight celebrity photographs are not: these people have succeeded (to borrow from Roland Barthes) in making *other bodies* for themselves, other bodies constituted in an image and confirmed in a photograph.

These photographs remind us of how much we who do not resemble celebrities strive nevertheless to *look* right, to have a look, to achieve an appearance that is suitable to us; in a sense, we strive to impersonate ourselves. At the heart of this exercise is the question that many of us ask ourselves at some point in our lives: "What would I look like if I looked like Marilyn Monroe in a photograph?"

# INTRODUCTION

Brian Howell

A while ago, I started taking pictures of celebrity impersonators after a string of chance encounters with look-alikes. When I began researching the subject, I had no idea that so many people made a living at it. I became intrigued, and as a result, this project was born. I attended a number of conventions for the celebrity impersonator industry; there are two major gatherings a year: Las Vegas in the spring and Orlando, Florida in the fall. The impersonators are there to showcase their talent and to network with others in the industry; the conventions are like any other, except that on any given day, you might see George W. Bush hamming it up with Ozzy Osbourne, or bump into Marilyn Monroe wearing her dress from *The Seven Year Itch*, except there is no subway air vent to blow it up to her waist.

Impersonation is a full-time career for many of the people who appear in this book. Some of them make a great living at it, including a few who look more like the celebrity they impersonate than the actual celebrity himself. While getting to know them better, I've learned that the biggest misconception about impersonators is that they are somehow obsessed fans desperate to physically become the celebrity they impersonate. But I never met anyone like that. On the contrary, many impersonators got into the business because of others—those passersby on the street who stop and stare, and ask, "Has anyone ever told you you look like...?" Simply put, and not in a derogatory way, impersonators are opportunistic, taking advantage of a culture with an insatiable, uncontrollable thirst for celebrity and all that it entails.

"I absolutely love bringing the legendary Marilyn Monroe back into the present for my audiences. Because I am a big fan of hers, I think it helps to create an illusion of what it might have been like for the audience to experience being around Marilyn, and what it might have been like to see her onstage in a show. I always try to insert a heaping spoonful of Marilyn's fabulous wit and humor into the show, as well as capturing her essence by talking, acting, and looking like her as much as I can. I interact with my audiences, giving each show a personal feel and making every show unique."

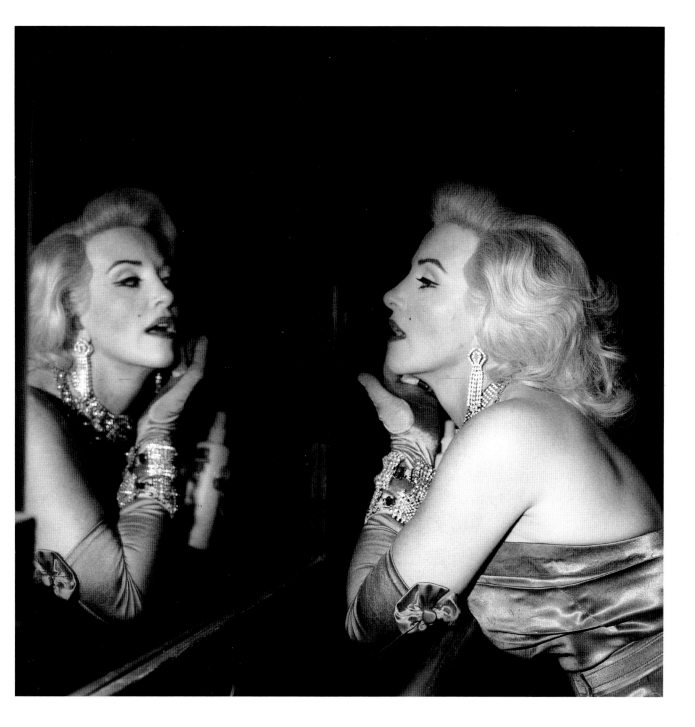

"Madonna is a character with limitless possibilities. For over half of my life, I have held the unique occupation of portraying her, one of the world's most influential, glamorous, and controversial stars. Even after achieving icon status and inspiring millions worldwide, Madonna is still a work-in-progress. Her persona continues to captivate me, keeping my career as a look-alike challenging and evolving, right along with hers. This is what has held my interest in the work I do for so long.

"Paying tribute to her can be exhausting. Madonna is like a superhero—lacking any physical flaws and functioning with superhuman discipline. Sometimes I don't want perfection; sometimes I just want to kick back and live a mortal life. I'd like to gain a few pounds, eat what I want, color my hair and cut it ... but in this work you cannot have it both ways and be successful. It is a mixed blessing because, while I enjoy what I do, I try to balance it with my personal life and still be me. I do not want to look back on my life and feel like I have always lived through someone else's image, vicariously. You need a good sense of self to be able to take on another person's character, especially when you resemble them naturally. You have to be able to separate where that person ends and you begin in your daily life, and I think a lot of people find that challenging in this business.

"While working as a Madonna look-alike, I've come to realize that her career is a study in American pop culture, and that she herself often emulates many successful entertainers and artists from the past. At the same time, she has redefined these attributes into a style that she can legitimately call her own. It shows me how we all influence one another, and that it all comes full circle."

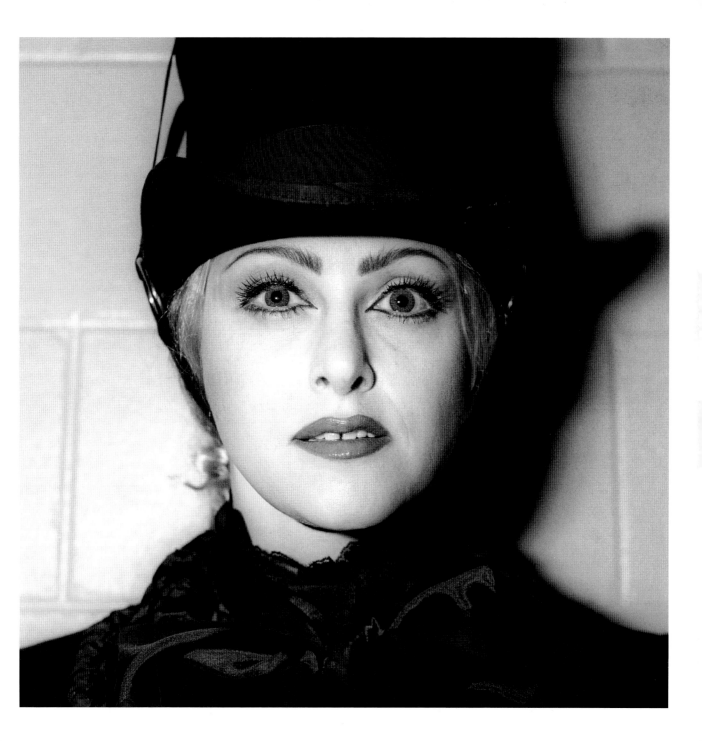

"I was in Northern Brooklyn and Robert De Niro grew up in the Little Italy area of Manhattan. Along with the bone structure, skin tone, and the general ancestry, we have the same walk and talk and all that stuff. It's not like I grew up on a farm in Iowa or something; we probably went to the same movie theaters and rode over the same roadways and subways.

"The first time that someone spotted me [as a De Niro look-alike] was when I had just gotten out of the army. I had been in Vietnam and wore my green army jacket a lot. With my short haircut and a gold Camaro, I would stop at red lights in New York City and people would do double takes and stare at me. De Niro wore a green army jacket and drove a yellow cab as Travis Bickle in *Taxi Driver*.

"For the first ten years I didn't really think I looked like the guy. Then I saw *Midnight Run* and I had an epiphany. De Niro was wearing the same black leather jacket that I wore as a teenager ... that was the first time I saw Joe Manuella as Robert De Niro."

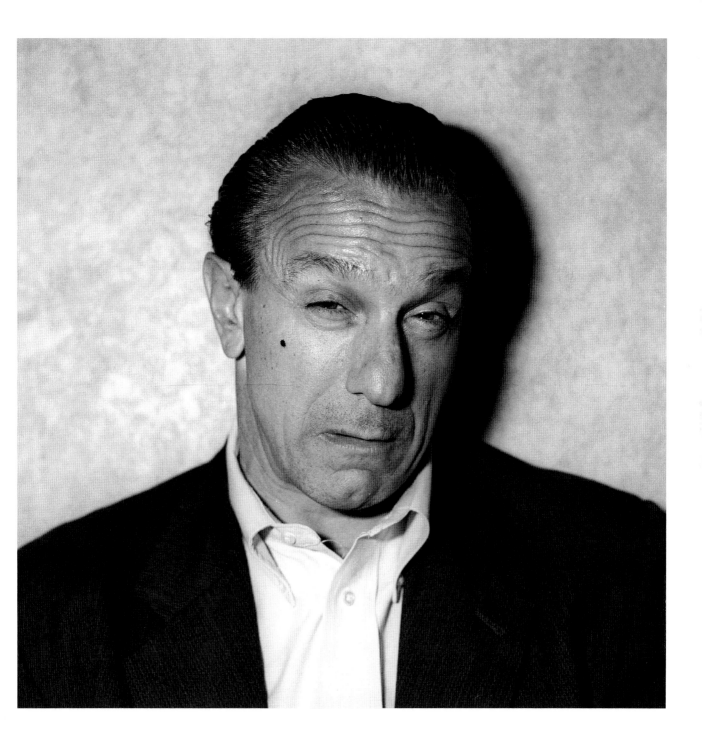

"There are worse things in the world than looking like Johnny Depp."

Danny Lopez has more in common with Johnny Depp than looks. Not only was he born on the same day as Depp—June 9, 1963—but they both have two sisters and a brother; further, Danny's brother's name is Johnny and Depp's is Danny.

Lopez's resemblance to Depp has given him a taste of what the actor experiences when in public: "I know what it's like to be hit up at the airport for pictures and to be stared at while eating. Celebrities can't always go out. Johnny doesn't go out; he's a recluse.

"We [impersonators] actually experience fame on a lot more levels than they do. Sometimes I want to be left alone. But you don't want to represent your star as a jerk, so there is some responsibility in a weird kind of way."

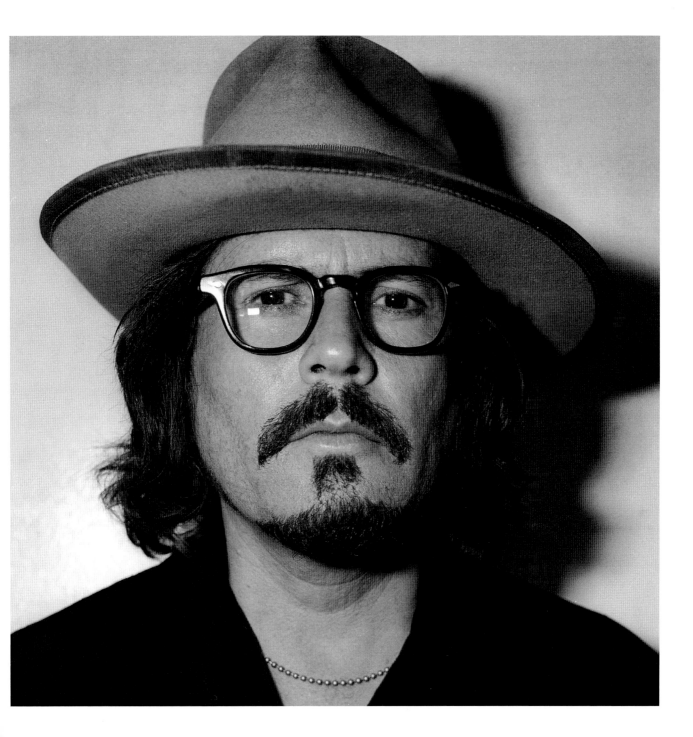

"I met Paris Hilton in person, when I worked on her reality TV show *The Simple Life*. She's really sweet. It was cool to meet her, but I wasn't as surprised or excited to meet her as she was me. I already knew about her and act like her all the time, so to me, it was just normal. She said, 'Oh my god, you look like me—that's hot,' as she was running out the door of a nightclub. That was cool.

"Celebrities should be flattered by us because we're promoting them. It's the hugest form of flattery. I'm promoting Paris, meeting her fans and stuff, so I'm doing things that she wouldn't have time to do.

"I don't know how long I want to do it. I came to New York to become a model, but the agents said I looked too much like Paris Hilton and wouldn't take me on. Now I want to get into acting.

"When *Playboy* approached me I thought, 'Wow, *Playboy* is very Hollywood and a lot of actresses have posed for the magazine.' The world is becoming more open about nudity. So I figured it's not such a bad thing. I never, ever could have seen myself doing all of this."

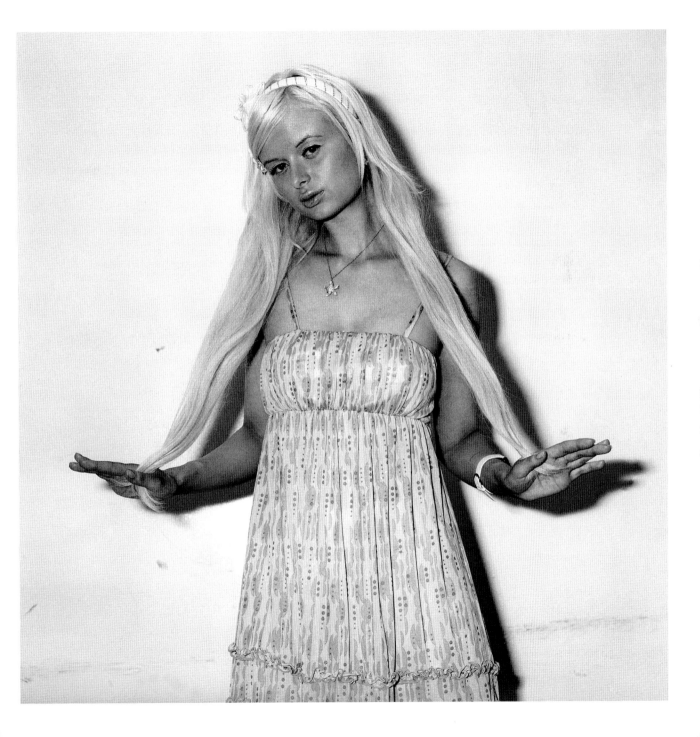

Richard DeFonzo saw the movie *Cabaret* for the first time when he was eight years old. When Richard pointed to the screen and told his mom he wanted to "meet that lady," she told him to go to his room. Many years later and after watching the film more than 100 times, Richard is a Liza Minnelli impersonator. He says: "Liza has always moved me. She's the greatest entertainer, ever. It's amazing to walk in the same shoes as this woman, to be adored, even for five minutes."

For Richard, an actor and writer, Liza is also a character. "After the show, the wig comes off and I go get a hamburger."

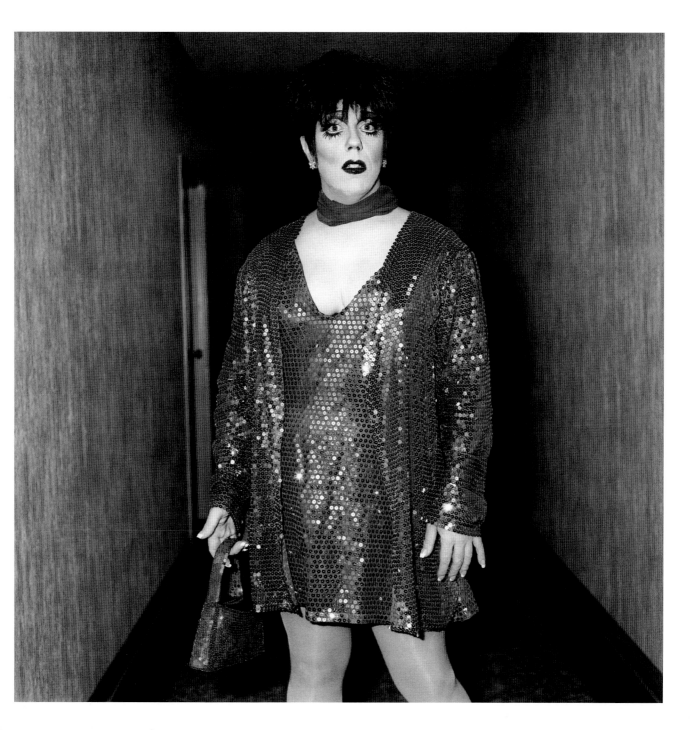

"After being told repeatedly that I look like Bobby Darin and even Donald Trump, last year I invested in a few wigs and spent hundreds of hours studying both of them. I launched my impersonations of them in late 2006.

"Some people think impersonators are a joke, to be made fun of or insulted with comments like, 'You can't replace the original.' What they don't realize is that we, the impersonators, are filling a need in the market. Audiences want to recapture the live act, the thrill of pretending and fantasizing about days gone by, or try to relive the past through the impersonator's performances. It is thrilling to be able to create an environment where I set a mood and suspend belief.

"I compare it to my childhood. When I played I was a Jet from *West Side Story*, a cowboy on a bucking bronco, an explorer discovering new worlds; I could fly like Superman and I raced Formula One cars at the Grand Prix. Why grow up when I can be a kid forever?"

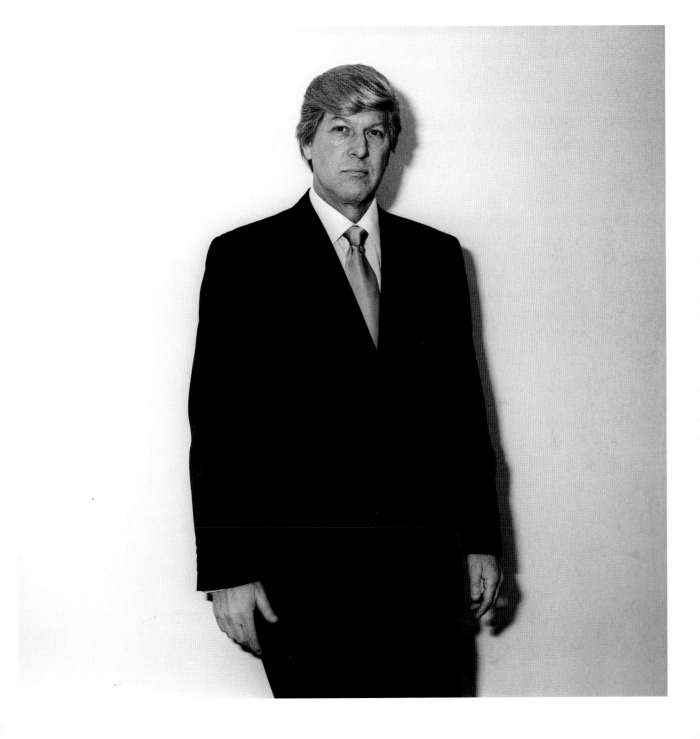

Mick 1: "I started out playing music in clubs back in the mid-1980s. The most common question I got was, 'Has anyone ever told you that you look like a young Mick Jagger?' This became a recurring theme throughout my career ... and here I am today."

Mick 2: "I was approached by a former Jerry Lee Lewis impersonator in Reno who convinced me to give it a shot. People had been telling me for years that I should do it, but it took him to convince me."

Mick 1: "Mick Jagger is one of the greatest icons in the history of rock and roll, and still going strong. Besides the physical resemblance, I give every live performance the energy and intensity of a stadium show no matter what size venue I'm playing—my job is to entertain."

Mick 2: "I've resembled him for so long. He likes a good time and so do I. Also, I've stayed skinny enough, and kept my hair. That helps a lot."

Mick 1: "Generally, people say I'm every bit Mick on stage; it's always nice to hear that. The only negative responses I've had have been from jealous boyfriends after their girls jump on stage with me, but overall people understand that it's all in fun. The downside is that sometimes people forget there's more to me than being an impersonator. I admit I've had days when I've felt like a one-trick pony, but that passes quickly. Overall my looks have served me well, I suppose."

Mick 2: "It's a kick. Some people really get excited and want to tell me stories about how much they love the Stones or Mick. I feel good after those meetings."

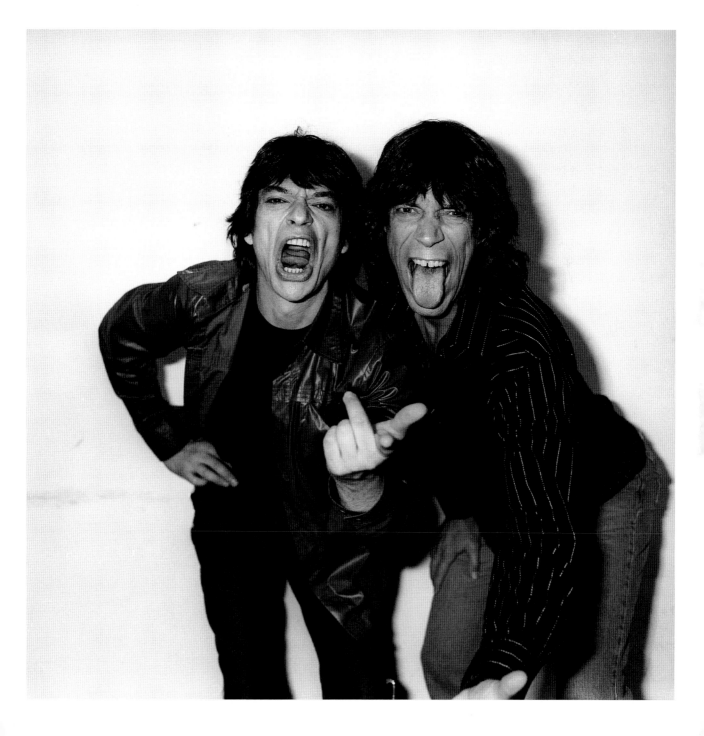

"I have looked like Jack Nicholson all my life. In 1971, my aunt told me I needed to see *Five Easy Pieces*, that I looked just like the actor in it. Nine years ago, my wife finally convinced me to get into the look-alike business.

"As far as similarities go, it's just 'the look' and the voice. Jack, as you know, is a prankster. I am also. People respond to me in many different ways. At the airport, corporate events, etc., I take pictures with people so they can lie to their friends. I meet all kinds of people and I think it's a blast—and a great retirement plan."

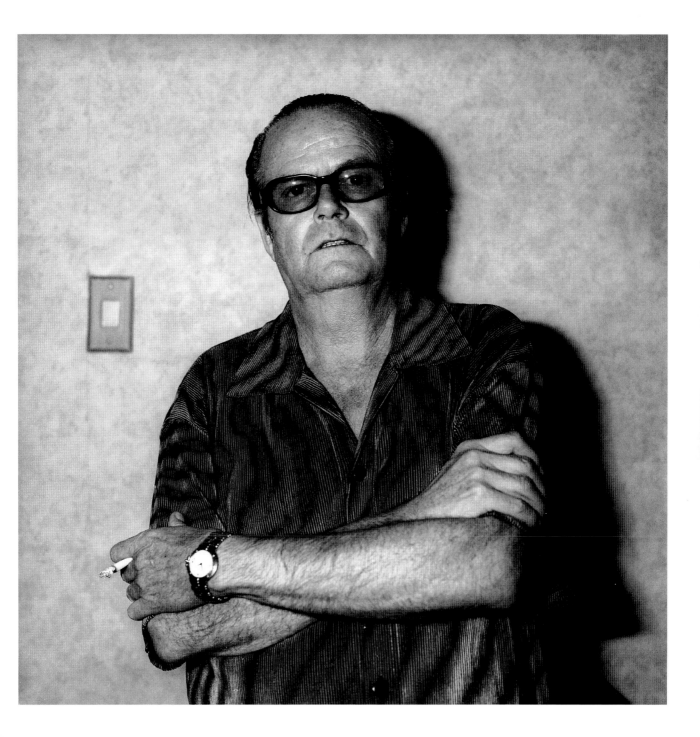

"After Angelina Jolie did *Lara Croft: Tomb Raider* in 2001, every single time I went out people told me I looked like her. At first I didn't care, then for a while the attention made me nervous or embarrassed. Now I've become more confident, and I notice people gawk at me all the time. I'm not just me anymore. A part of me is Angelina Jolie, and a part of her has become a part of my identity."

"Jennifer Aniston is likeable, and that helps, because if people like her they like me too. I love her style, she's just real simple, classic, and all-American, just like me. I have been told that I look like her ever since *Friends* first aired, when I returned home from college and my mom had the latest issue of *People* magazine. She pointed to the cast photo and said, 'You look exactly like this girl.'

"One time when I was in New York, I saw a street vendor selling fake designer purses out of a plastic bag, so I stopped and bought a thirty-dollar fake Prada bag. A girl walked up to me and said, 'Oh my God, Jennifer Aniston, can I please have your autograph?' And I said, 'Honey, do you really think Jennifer Aniston would be on the street buying a fake Prada out of a trash bag?' But she didn't believe me."

"Although the late, great Steve McQueen has been gone for over twenty-five years, his legend lives on. For many years, I have often been compared to Steve McQueen. So often, in fact, that some people now call me Steve. I have been very fortunate in participating in the re-creation of his legendary past. Just as he did, I act and portray a character—Steve McQueen the Hero, the Idol, the Legend. I want to help his name live on.

"Once when I was at Grauman's Chinese Theatre in Hollywood, I came across Steve McQueen's footprints. When I stood in them to have my photo taken, I discovered they were a perfect fit."

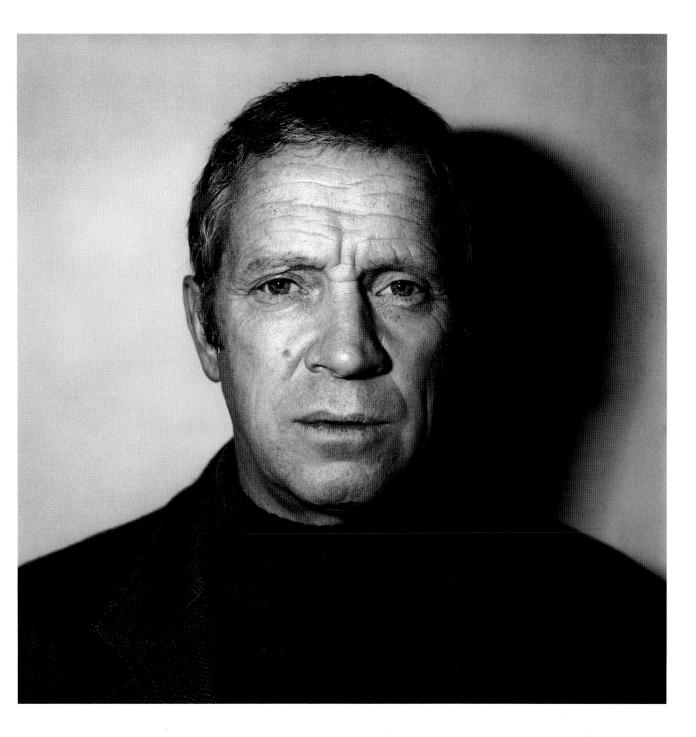

"I have been working as a model with the Ford modeling agency since 2001, and doing the look-alike stuff since 2002. I love the work; it's a lot of fun and I get a little taste of what Richard Gere may go through every day of his life. It's wild."

"I've never walked around and thought of myself as Bono. I suppose we share lots of the same politics, and I'm a huge fan of U2's music. It's a great feeling to be a part of U2 in some odd way, but I take no credit for it. In the great scheme of things, it's just a small, humble feeling to know that someone out there moves so many people.

"One day I met the President of Ireland, Mary McAleese. I was in Dublin doing an impersonation gig at a surgical supplies convention where she was scheduled to do a speech. I was about to leave when she walked in with two bodyguards. I was on the sidelines with the ten or so people there to greet her. She looked me up and down and said, 'You're looking well,' to which I responded in an Irish brogue, 'Thanks, Mary, so are you.' I sent her a copy of the poems I wrote while I was there, knowing how the Irish have that poetic spirit, and a CD of my classically influenced piano compositions. A letter from her office arrived a few weeks later thanking me for the laugh and the gifts.

"I've done lots of work before I decided to pursue this as a profession. In high school, I did a lot of singing at old folks' homes and the like. But it wasn't until college that I stepped up my community involvement, becoming president of the campus YMCA, the International Students' Union, and of a volunteer organization called Community Service Network. I was also involved in a program called Best Buddies, which is modeled after the Big Brother program and deals with special needs kids. After college, I went to Romania to volunteer with the handicapped orphans, then I joined a group that does medical training and disaster relief all over the world. I've been to Missouri five times rebuilding homes for flood victims, and I was recently in Mississippi rebuilding homes for Hurricane Katrina victims."

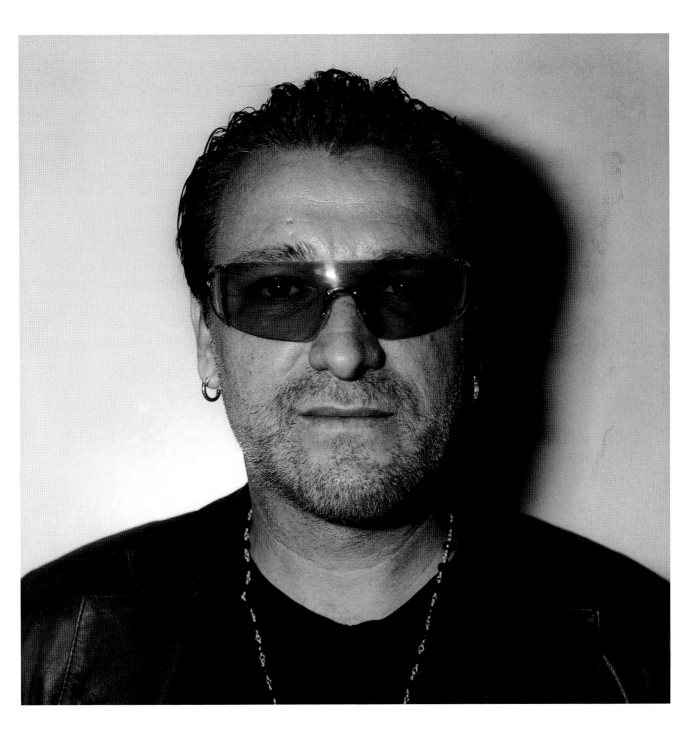

The impersonator industry holds two annual conventions: one in Las Vegas, Nevada in the spring and the other Orlando, Florida in the fall. Agents, talent buyers, costume manufacturers, photographers, the media, and even plastic surgeons show up to watch and do business with impersonators who get an opportunity to showcase their talent and reconnect with the impersonator community.

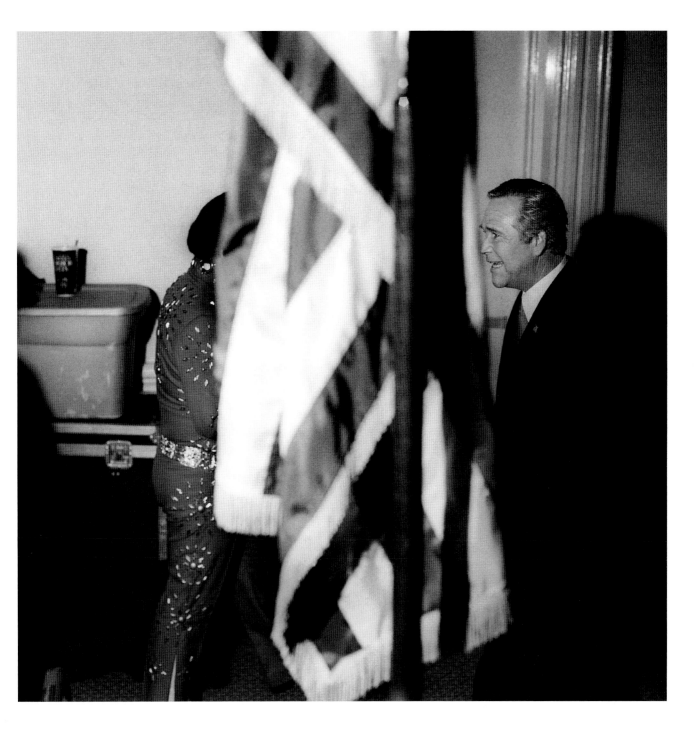

Lyndall Grant's career took a radical twist in 2003 when Arnold Schwarzenegger, an A-list celebrity at the top of his game, was elected Governor of California. Like Ronald Reagan decades before him, Schwarzenegger made the transition from movie star to politician. As a result, his impersonator had to make a similar shift:

"It quickly became apparent that Arnold the real person is much more complex, more intelligent, more affable, than Arnold the movie character. Plus, the man has a sense of humor and wit. When he became Governor, I suddenly found myself unable to use my trademark *Terminator* sunglasses, boots, and leather pants. Instead, I had to wear a suit and give speeches from a podium."

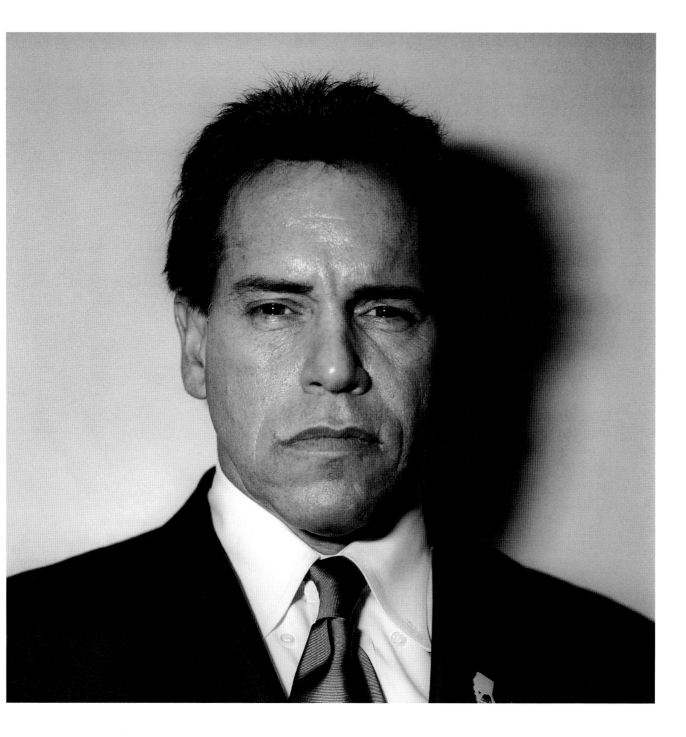

"As George W. Bush's popularity has gone down the toilet, it has really cut down on my work opportunities. People want to hire me to do garbage stuff against him and that ain't cool.

"I recently did a gig in Seattle, a roast for a guy who was retiring from some company. When I walked into the room, he said, 'What the hell is he doing here?' It was a good gig, but most of the audience just hated Bush and it's hard to get laughs out of people when they're booing."

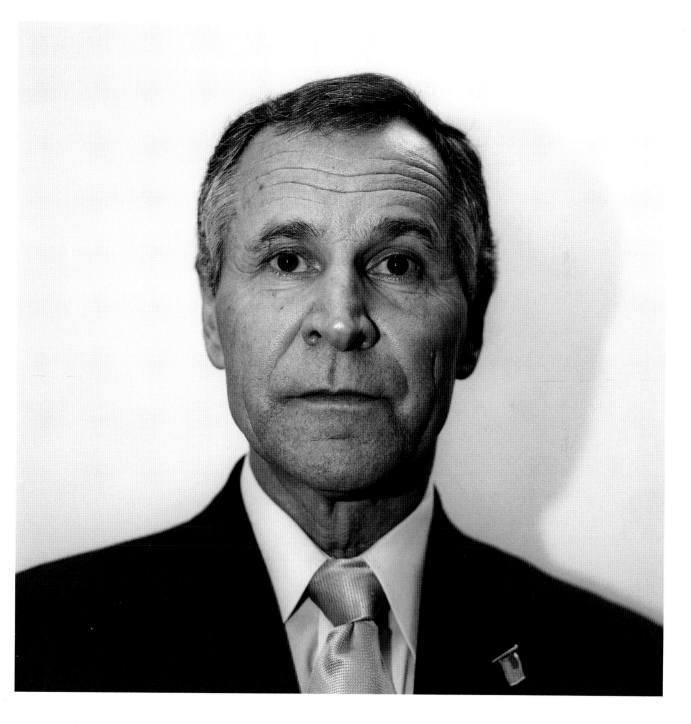

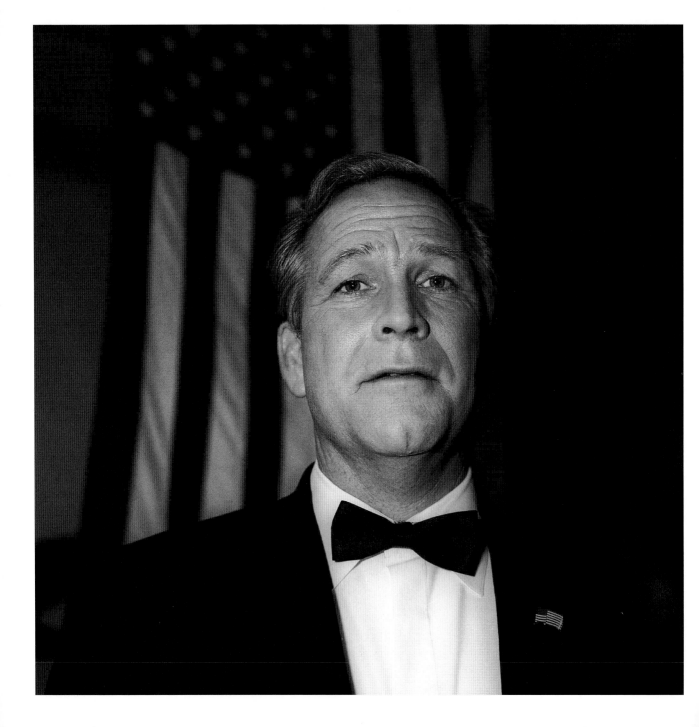

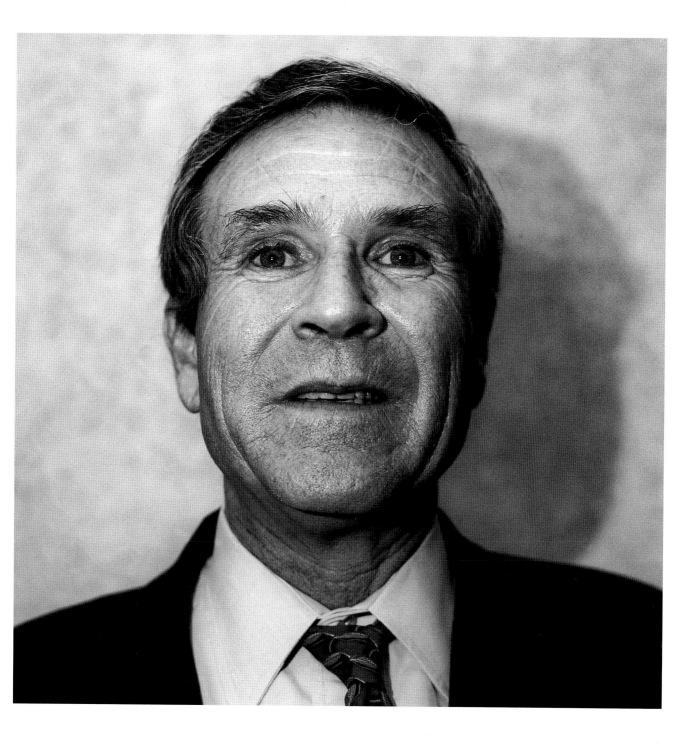

"I probably had more fun being Saddam Hussein than Saddam himself did in his last years.

"I prefer to portray Saddam in a humorous light. I did a serious portrayal of him once, for an HBO movie called *Live from Baghdad* starring Michael Keaton. It was about CNN's coverage of the 1991 Gulf War, when they got an interview with Saddam. I acted serious then, but otherwise my impersonations have all been spoofs. This is not a guy that I want to pay homage to.

"One night I was in a cab in Washington, DC. My driver, who was Russian, let me out briefly to see the Lincoln Memorial, and when I returned he and another Russian cabbie were laughing. He said, 'I'm very sorry for laughing, sir, but my friend and I agree that you look a lot like someone who isn't very nice.' I said, 'That's okay because I play him in the movies.' His eyes widened and he said, 'You play Joseph Stalin in the movies?' And I thought, there's my backup career. It's apparent that if you kill millions of people, I can play you in the movies."

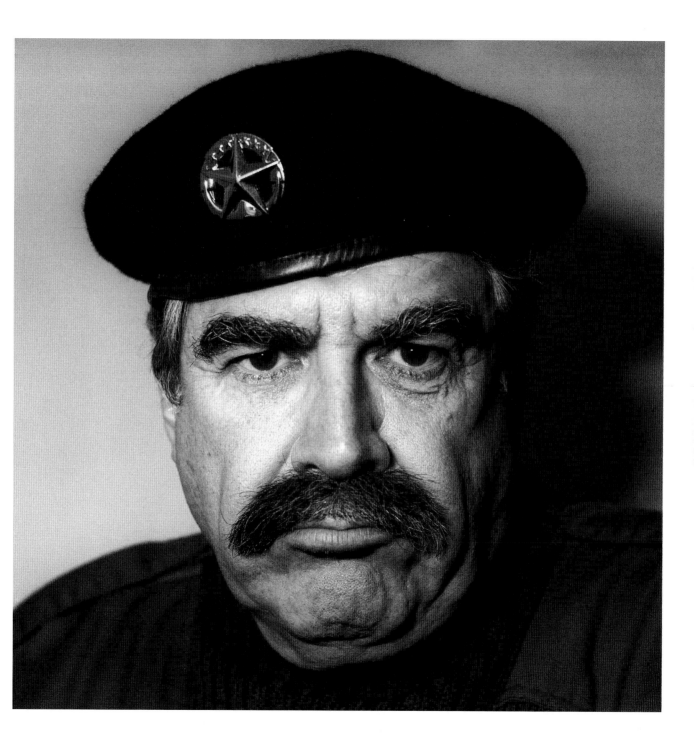

President Clinton and Hulk Hogan look-alikes talk backstage at the 2006 Sunburst Convention of Celebrity Impersonators and Look-Alikes, Orlando, Florida.

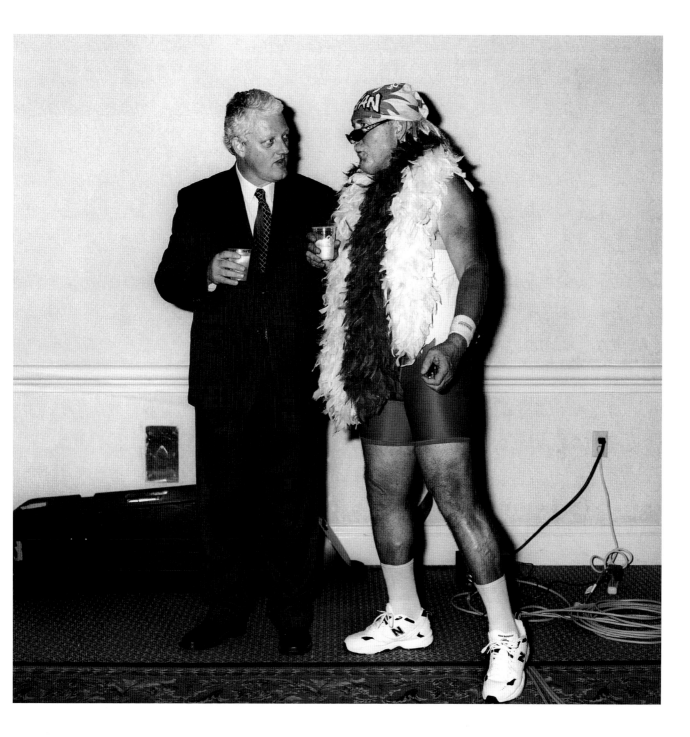

"The responses to me as Hillary Clinton are very polarized. People either love her or hate her. In the South, I get more of the latter. Often I feel they forget they're talking to an impersonator and start relating to me as if I really am her; one man wanted to debate the abortion issue with me, for heaven's sake. I must take some credit for my acting skills if I can get them to suspend disbelief so thoroughly, but maybe it's just that she triggers something.

"Sometimes I feel I am seeing the world through her eyes, having her experiences. Hillary Clinton supporters will give me the thumbs-up sign and say, 'Let's win in '08.' At a convention of meeting planners last year, there was an announcement that a special guest, Hillary Clinton (me), was there to address the luncheon. I heard someone in the audience say, annoyed, 'Who invited her? I don't want *her* here.' You would think a roomful of meeting planners who routinely hire celebrity impersonators and other specialty acts would have guessed that this was part of the entertainment, but maybe even the idea of Hillary knocked the sense out of them."

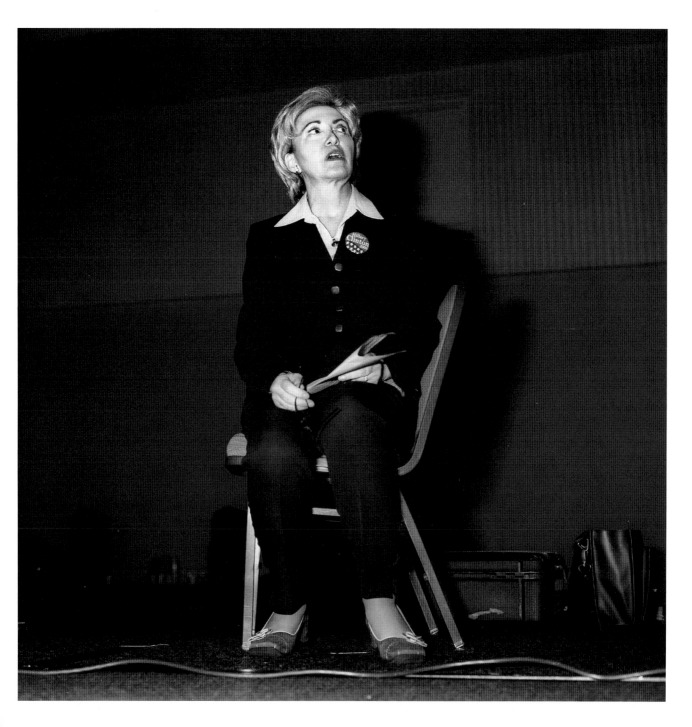

Miguel Maldonado, a former corrections officer at Rikers Island, New York City's largest jail, has great admiration for Colin Powell. Along with sharing a resemblance to the former US Secretary of State, they both did two tours in Vietnam. And both of their wives are named Alma.

"I sent him a letter with all the pictures [of my look-alike work] and he sent me back a letter thanking me for my Vietnam service. He signed it, 'Best wishes, Colin Powell.'

"I identify with him a lot. I try not to embarrass him. I've been asked to tell jokes, but he doesn't tell jokes. It would be nice if he ran for president. That would certainly secure some work for me."

When Maldonado served in the military, he reached the rank of sergeant. He wears his actual Class A officer's uniform when he performs—he simply changes the stripes on the epaulets to stars, making him a general. Half of the medals he wears are from his service Vietnam.

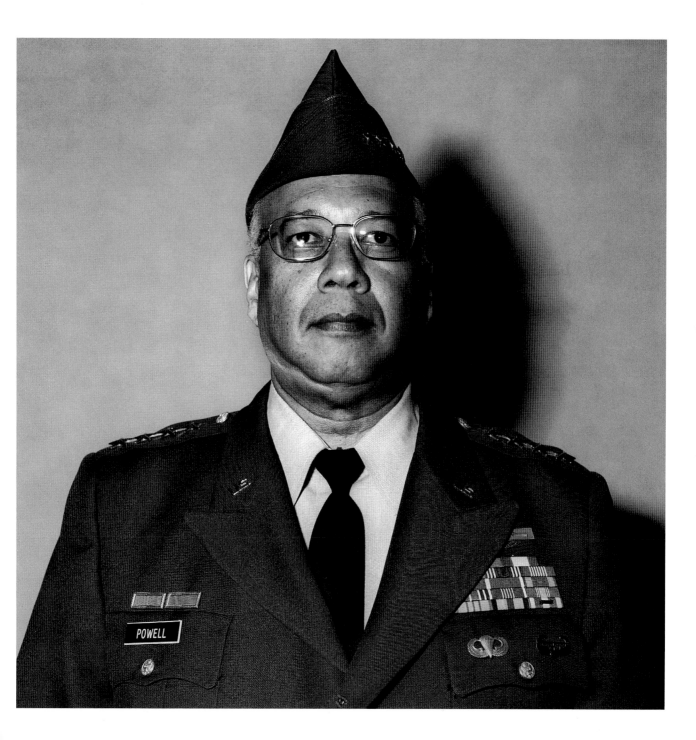

"I have been portraying Colonel Sanders since retiring from IBM in 1991, when I entered a look-alike contest at the World Chicken Festival in London, Kentucky.

"Although I have never done the genealogy, there is a remote possibility that I may be related to the Colonel. My great-grandmother was a Sanders prior to her marriage to my great-grandfather. I've done considerable reading about his life, and even met him in person before I had any idea that I would be portraying him.

"My latest appearance as the Colonel was sponsored by KFC. I was the escort for a Queen Elizabeth II look-alike at the Kentucky Derby. On Kentucky Oaks Day, the day before the derby, I was videotaped for a spot on *The Tonight Show with Jay Leno*, along with 'Ross the Intern.' KFC has also been using me for promotions, including a regional mangers' meeting in Orlando, Florida, and a franchise meeting in California, where I did radio and TV commercials.

"I will soon be posing for a picture that will be used to build a statue of the Colonel at the Shelbyville, Kentucky Jewish Hospital, where he made a significant monetary contribution for cancer research."

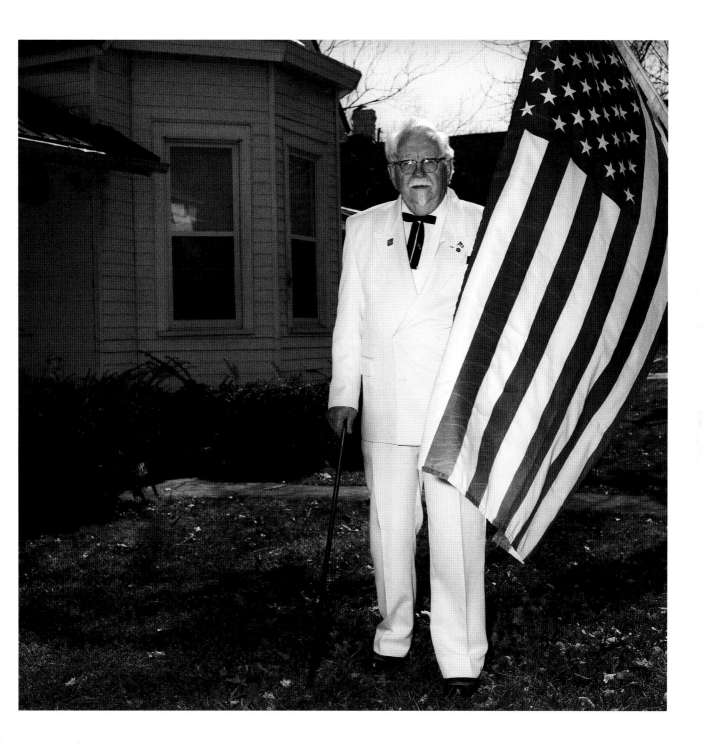

"William Shatner and I have the same jacket size, we're the same height and weight most of the time, and we both have a 'captainly' disposition and natural good looks, but I'm twenty years younger and my hair is real, but thinning. Some characters come and go, but my character is legendary and will go on forever."

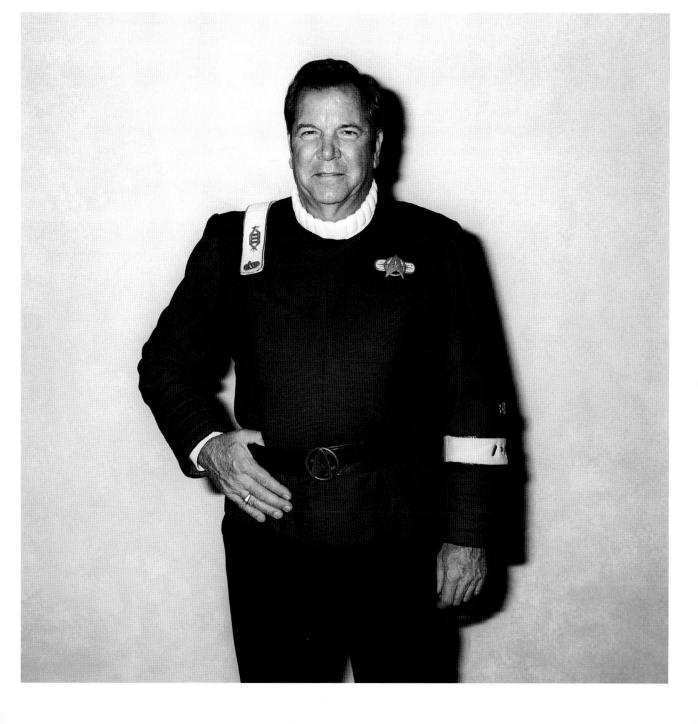

"Once I was at a film premiere as Trinity [from *The Matrix*]. I was signing my photographs, and the line at the table got pretty long. Most of the 'fans' were children and young adults, once in a while a grandpa or two, but on this day, one particular fan stood out. She was a middle-aged woman who looked like she should have been at a high tea, not in a movie lobby with noisy kids. I wondered how this lady even knew about my character or *The Matrix* films. She asked if she could have two photos. 'Of course you can,' I told her, and I began thinking of what I would write, as I always write something that fits the fan in a sci-fi sort of way. Just then, she bent over and told me who the photos were for, and gave me their names. It turns out they were for her only children, a young man and woman, both serving in Iraq. She told me that they were huge *Matrix* fans, and these pictures would go up on their tent walls. Well, those words hit me funny, my eyes flooded, and let's just say it's a good thing that Trinity wears sunglasses. I hope her children are back home safely now. I will never know."

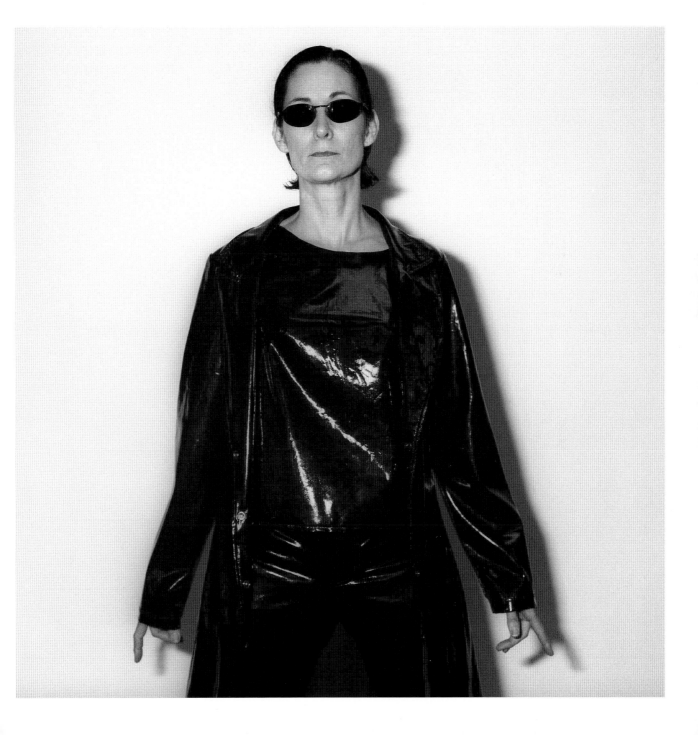

Manny Caso's life has many parallels to Tony Manero, John Travolta's character in *Saturday Night Fever*. Even though Manny grew up in Miami [rather than Brooklyn], he lived the same kind of life as the disco king. He said proudly, "Travolta told my life story in that movie." Now, even all these years later, Manny has the same physical attributes as Manero: facial features, body proportion, and skin and hair color. They even share the same astrological sign, Aquarius.

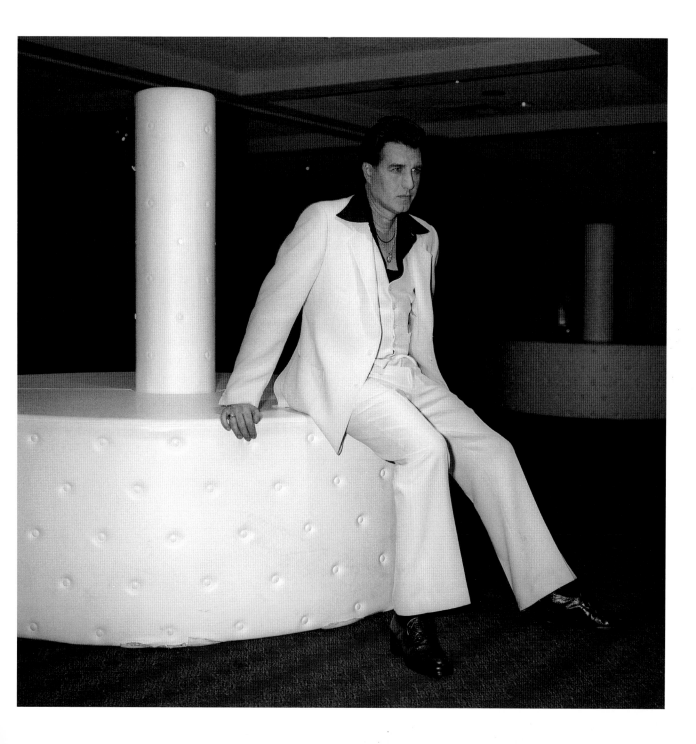

Al Smith, who impersonates Tiger Woods, also plays golf and has a personalized license plate that reads *NOT HIM*.

"Not a day goes by that I'm not recognized, no matter what I'm wearing. If I do dress like him, traffic stops. His old house is about two blocks from where I live. We actually work out in the same gym and shop at the same grocery store.

"Once while I was shopping, a lady followed me and said, 'Are you who I think you are?' I said, 'No, but I get mistaken for him.' She said, 'Are you sure?' I said, 'Honest, ma'am. I'm not him.' I continued to do my shopping and as I walked out the front door, she's waiting for me with a pen and paper. She said, 'I have to get an autograph. My husband is the biggest fan.' I said, 'Honestly, ma'am. I'm not him.' 'Let me see your ID,' she said. So I showed her my ID. She read my name, Al Smith, and she said, 'That's a fake name.' I signed her paper, 'Al Smith.' She still didn't believe me."

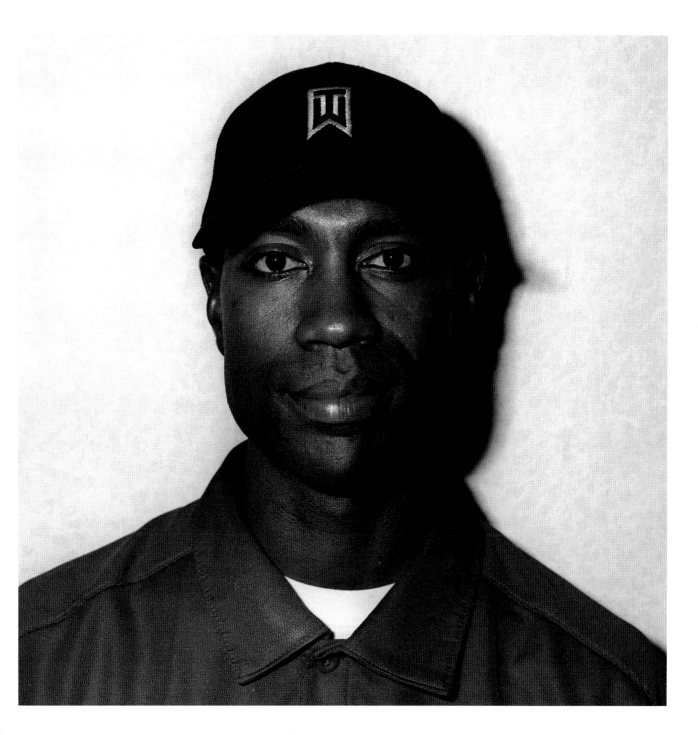

"As a young technician working for the Bell System in various cities throughout the country, my co-workers and customers constantly reminded me that I bore a striking resemblance to Sean Connery. This, of course, appealed to me as I was a big fan of his. It was then that I decided to have some fun with it. I knew that looking like Sean was not enough, so I dedicated myself to observing him more closely in his movies. I memorized his quips and lines and delivered them in his Scottish brogue. It wasn't long before I could converse completely as Sean Connery. This took a lot of practice and today I am completely at home in the character of Sir Sean. Ultimately, it was the encouragement of family, friends, customers, and strangers that was the catalyst for what is now my passion."

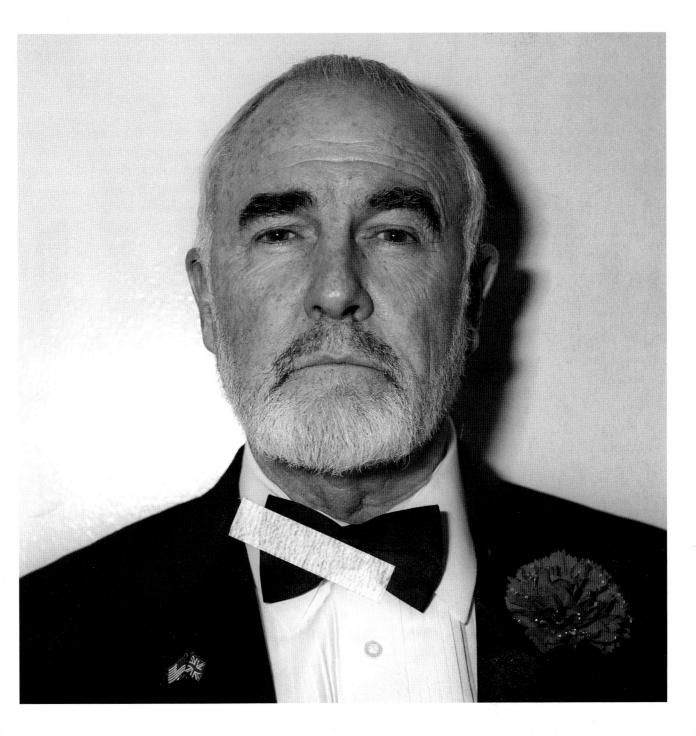

"Mike Myers has a mole on the right side of his face and I have one too, in the same spot as his. That kind of freaked me out. In his interviews, he's a quiet guy who also can be very energetic. I'm basically the same; I'm a quiet guy who likes to explode occasionally. I also have my own style of humor, and I'm taking writing classes at Second City. Being a Mike Myers impersonator comes naturally for me. I'm not trying to be someone else; I'm in character.

"I'm originally from the former Yugoslavia. I came to the United States eleven years ago, when the movie *Wayne's World* was still popular. I was living in Chicago, and one day I was riding in the passenger seat of my friend's car. We stopped at an intersection and my window was open. A guy in the car beside us looked at me and said, 'Extreme close-up. Whoaaa.' I just rolled my window up, and when I got home, I looked in the mirror, thinking something was wrong with me.

"I didn't realize until a couple of years later when my friends told me to watch *Wayne's World* that I looked like that guy in the movie. When I saw the extreme close-up scene, I realized what the guy in the car was saying to me. There was nothing wrong with me—the guy was a fan of Mike Myers."

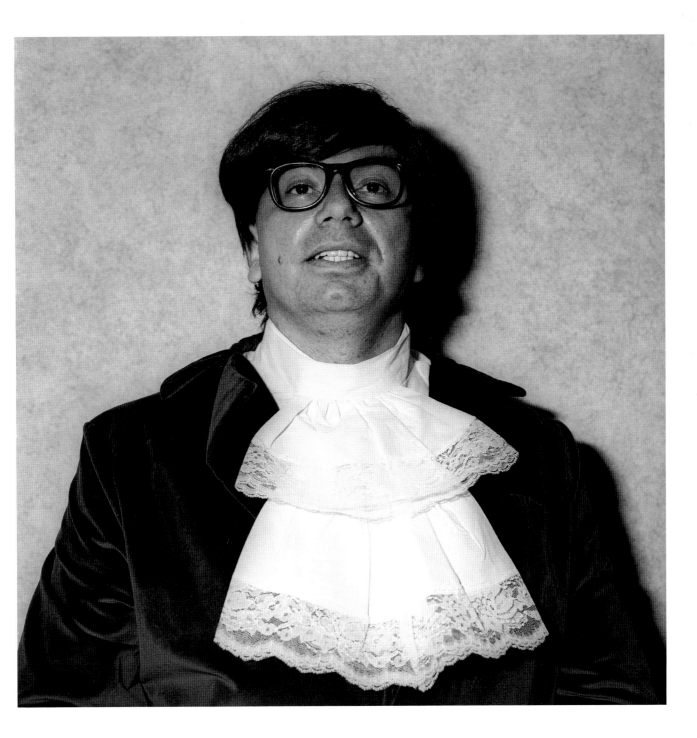

Peter Banks was one of the best Austin Powers impersonators in the business. He was British, after all. The former disc jockey left his native England, eventually settled in Las Vegas, and developed an Austin Powers show that also made use of his DJ skills.

Don Rugg, an Ozzy Osbourne impersonator, described the first time he ever met Peter Banks: "I was attending my first convention, sitting at the bar at the Imperial Palace. Peter was seated in character at the bar and shouted, 'Ozzy, you are positively shagadellic, baby.'" The two became friends and worked together over the next four years.

Peter was an upbeat and positive-minded entertainer with a tremendous sense of humor. He was diagnosed with cancer and eventually lost his hair from the chemotherapy treatments. But, as the show must go on, he showed up at the 2006 Celebrity Impersonators Convention in Las Vegas as Austin's bald-headed nemesis, Dr Evil. The dear friend to all in the impersonators industry passed away in August 2007 and will be missed by many.

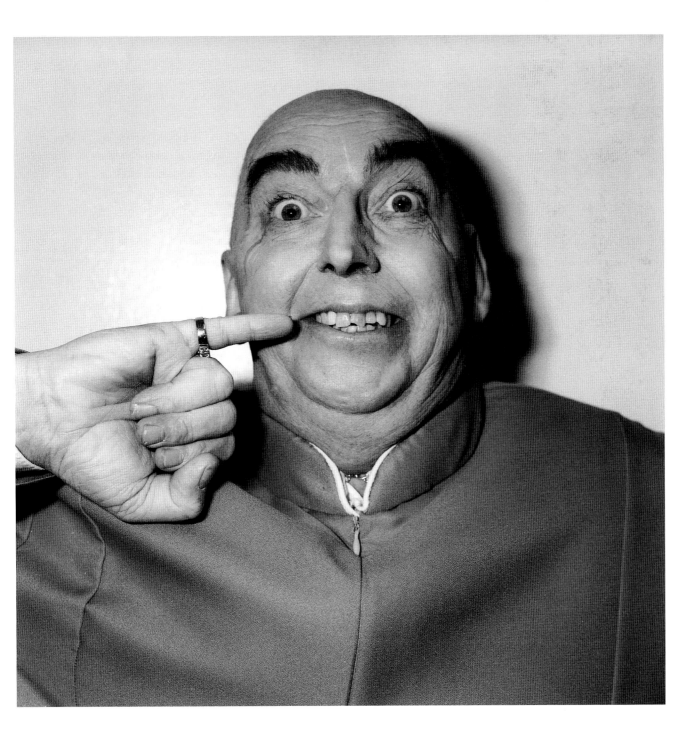

"Five years ago, people started telling me that I look like Tupac Shakur. Strippers, bouncers, girls at clubs, girls at strip clubs, bouncers at strip clubs, everybody. I was directing music videos around the same time, so I put two and two together and dressed up like Pac and shot a video lip-synching one of his songs. I even got the same tattoos as Tupac's done on my skin in temporary ink. I hit the gym a little harder for the physique, shaved my head, and grew some facial hair.

"While I was in full costume, I walked into a grocery store to buy some yogurt. All the bag boys stopped their work and surrounded me, saying, 'You look exactly like Tupac! What are you doing? Are you making a movie? What's the name of your company? Can we have a business card?' It was at this point that I realized I might have a little more on my hands than just a passing resemblance. I had originally started the project to gain attention for my directing career, but before long I was getting hired to attend private Hollywood parties and perform at women's clubs. Since I studied theater for many years and have a lot of experience performing at hip hop shows, I quickly learned Tupac's most popular songs and performed them live with the instrumental beats playing in the background. And that's how I became the world's first Tupac impersonator.

"It's funny 'cause I'm similar to Tupac in certain ways, but completely different from him in others. For instance, Tupac attended a school for the performing arts, and I did too. On the other hand, Tupac smoked a lot of weed, but me, I'm completely sober. Tupac wrote a screenplay while he was in a small jail cell; I wrote my first screenplay while living in a small Hollywood studio apartment. On the other hand, Tupac's script was all about the street life while my script was all about my penis. Go figure."

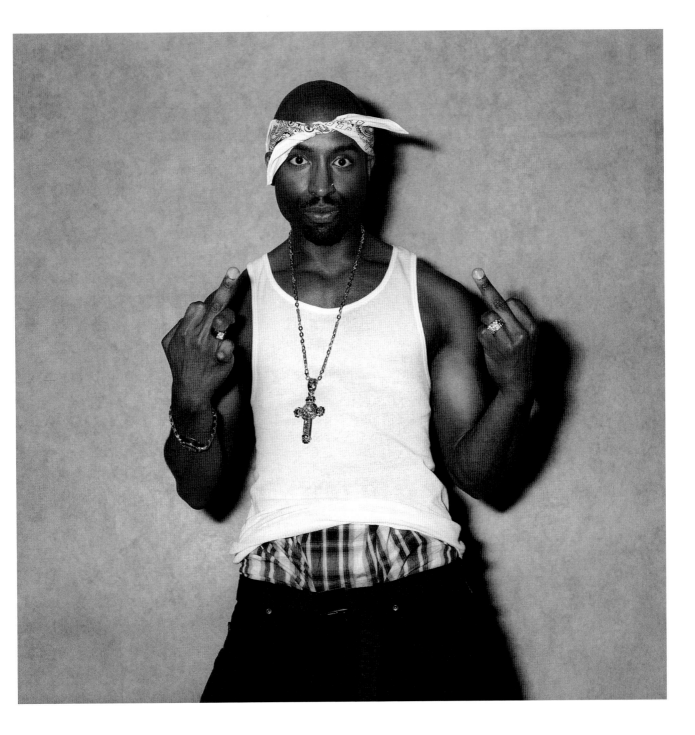

"My grandfather is from Birmingham, England, where Ozzy Osbourne was born. Ozzy and I both have a stutter when we talk, a limp when we walk, and a wife that tells us what to do and when to do it.

"We are both fathers who love their children. We sometimes don't like the choices our kids make, but that's how they learn. As with Ozzy's, my children have also had their run-ins with drugs. Fortunately, all have turned out clean and sober.

"My wife, like Sharon Osbourne, is an animal lover; we have two Pomeranians, one poodle, and two cats. She is now trying to talk me into a goat!

"I admire Ozzy for his tenacity. I really like his song, 'I Don't Wanna Stop.' With everything that he has been through in his life, nothing has stopped him—the drinking, drugs, failed marriage, jail, touring, ATV accident, Sharon's cancer. He has held it together. I can only hope to be that strong."

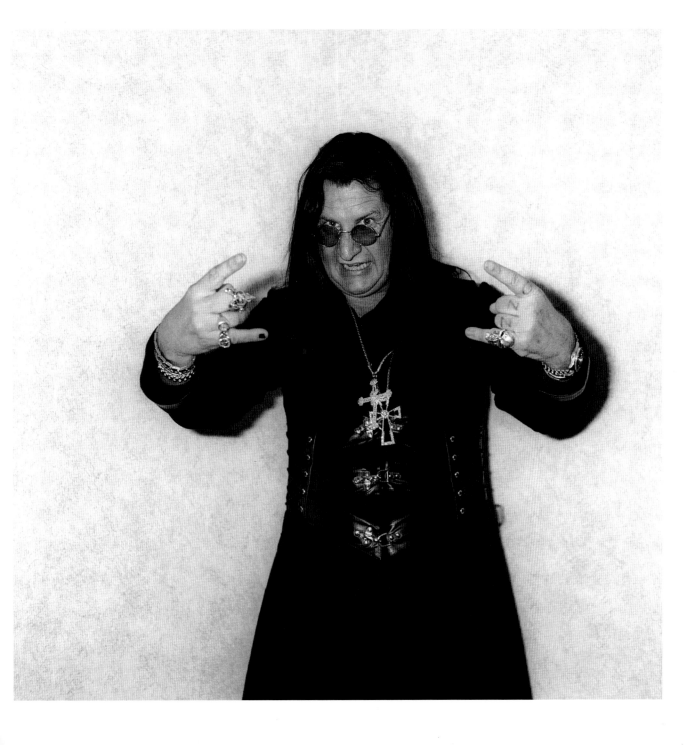

"When I started [impersonating Marilyn Manson], I had nothing: no wardrobe, no makeup, no contacts for my eyes. People always said I looked like him, so I wanted to see how I could really mess with people's minds. I got a whole lot of stuff together with the help of my girlfriend. The more I got into the look, the more I got into the music. Coming from an Air Force family, I was pretty much of a geek in high school; I didn't get a chance to dress up. I've always liked the punk and goth scene, and this was a great way to do it, through Manson. I like a little controversy, and Manson is definitely controversial. I get a lot of attention. And the people, God love them—for the most part, they want my autograph or picture. I've had parents tell their kids to go up to me. That's some crazy stuff right there—don't talk to strangers, but go say hi to the weird guy in makeup. But I've also had some people steer away from me, like I had some sort of disease, and a handful who were jealous or made fun of me. Oh well. I can't help it if I look so damn good.

"Sometimes I feel that agents are a little wary of me because of what Manson does; however, I do not have the same views of him. I have a Christian outlook on life. I always conduct myself in ways that are positive. For the most part, I am PG-rated. I don't see why people necessarily need much more than that. Whatever the case, I know that people will always want a Manson for their party."

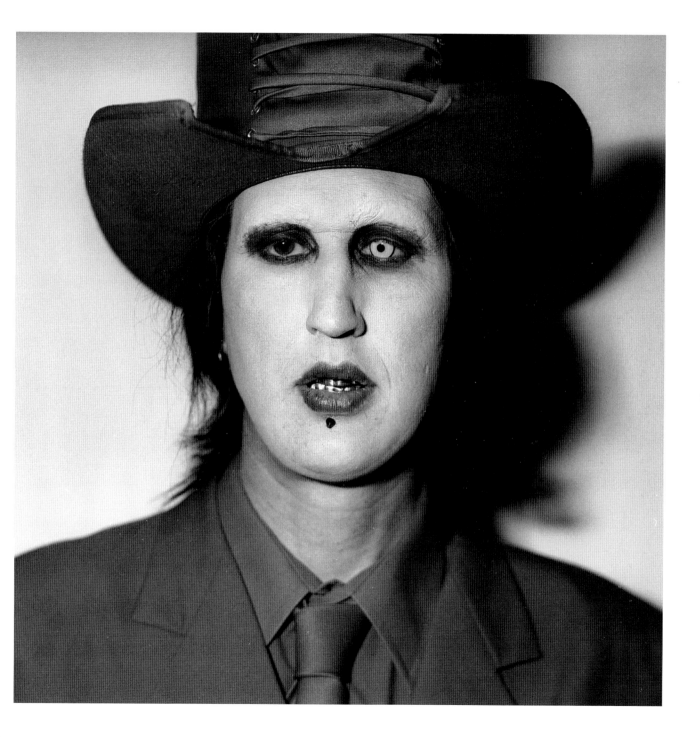

"I have been a musician since I was sixteen, and I used to sing and do impressions of Alice Cooper back then. I've always been a big fan. It wasn't until recently that I realized there may be a market for this, that I could be an impersonator and possibly make a living at it. So I started studying Alice Cooper more seriously to understand his mannerisms and vocal techniques, along with everything else. I also had to grow my hair long again and lose some weight! And I made replica costumes and props, like the Electric Chair and the Guillotine (along with a replica of my head … to get chopped off by the blade).

"It's been a lot of work, but a totally great experience. I've now been doing it for three years, and I get more comfortable onstage every time I perform."

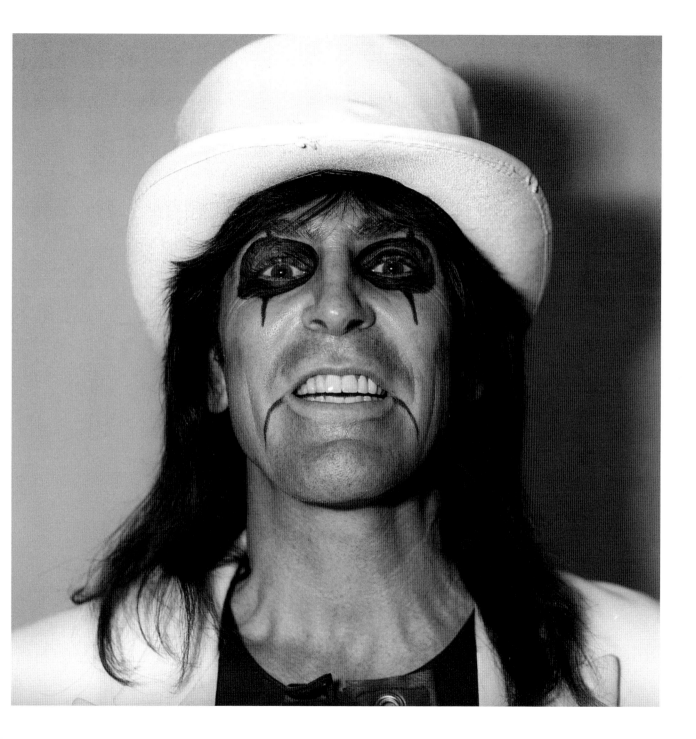

There are now at least 70,000 Elvis impersonators around the world. When Elvis died in 1977, there were between thirty-seven and 150. At this rate of growth, *The Times* of London speculates that by 2020, roughly one-tenth of the world's population will be impersonating Elvis.

After Elvis Presley, Marilyn Monroe is the most popular character for look-alikes to portray. When tribute artist shows first started, the performers were paying homage to stars who were dead; they impersonated musicians for the most part, and the shows were concerts which featured look-alikes such as Presley, Janis Joplin, Buddy Holly, and others.

In today's culture, the media bombards us with an endless stream of celebrity images and stories. We know more about the lives of some stars than we do our own family members or neighbors. This thirst for celebrity has enabled the impersonator industry to thrive.

"Having my celebrity inspiration pass away so suddenly at the peak of her fame was shocking, to say the least. The day Anna Nicole Smith died, I had been performing all day on a casino ship as Marilyn Monroe, one of my other characters. I received phone calls and emails from all over the country and abroad with condolences. I was stunned. It couldn't be true. Her son's death had already been a shock to me, being a mom myself. I couldn't believe she was gone. It was so tragic.

"She was always so filled with life, laughing and childlike. It's such a sad thing when a young life is cut short. We will never know what kind of accomplishments she was capable of. People seem to love her even more now than they did before. I think it's because all the media coverage revealed new facets of her personality. Now people realize that she was just a hometown girl from Texas at heart, with big dreams. Hopefully, I can do Anna Nicole justice in my tribute performances. I like to think she would approve, since she emulated Marilyn Monroe herself in so many of her performances."

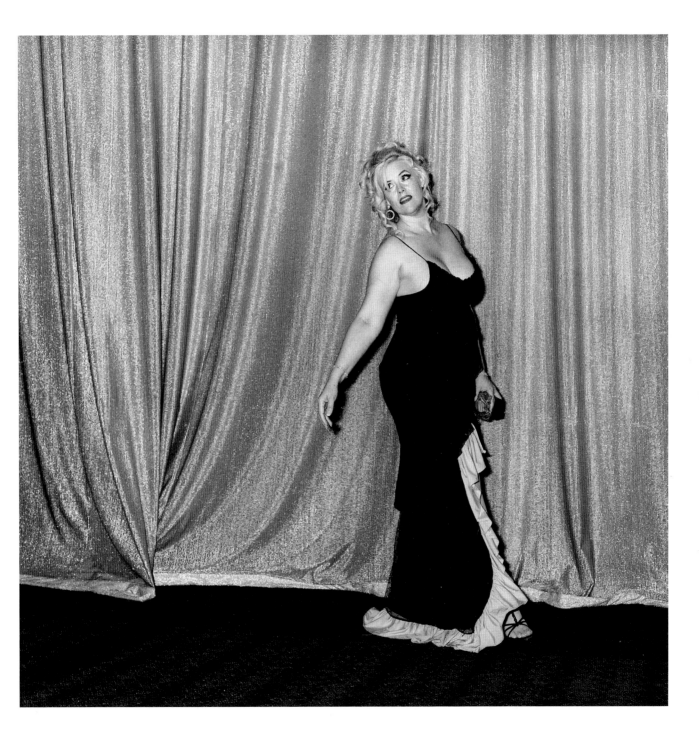

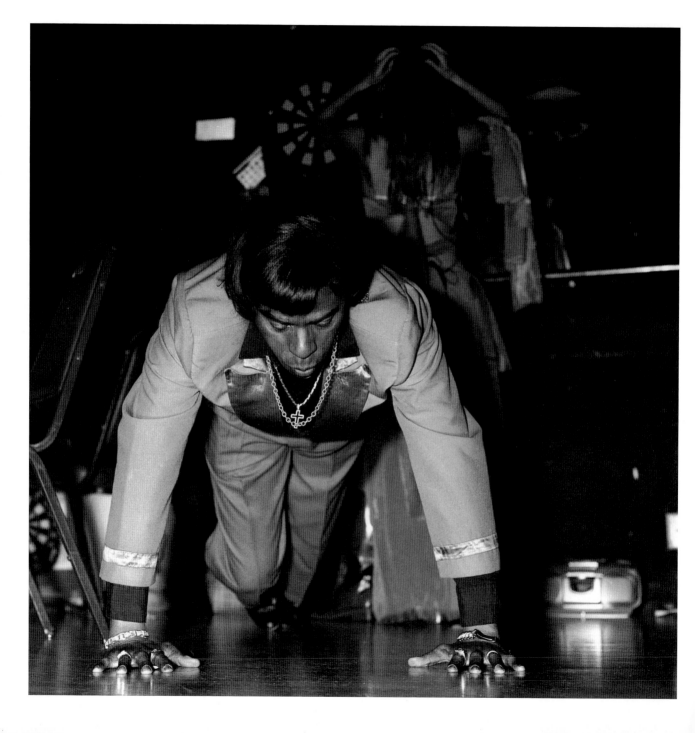

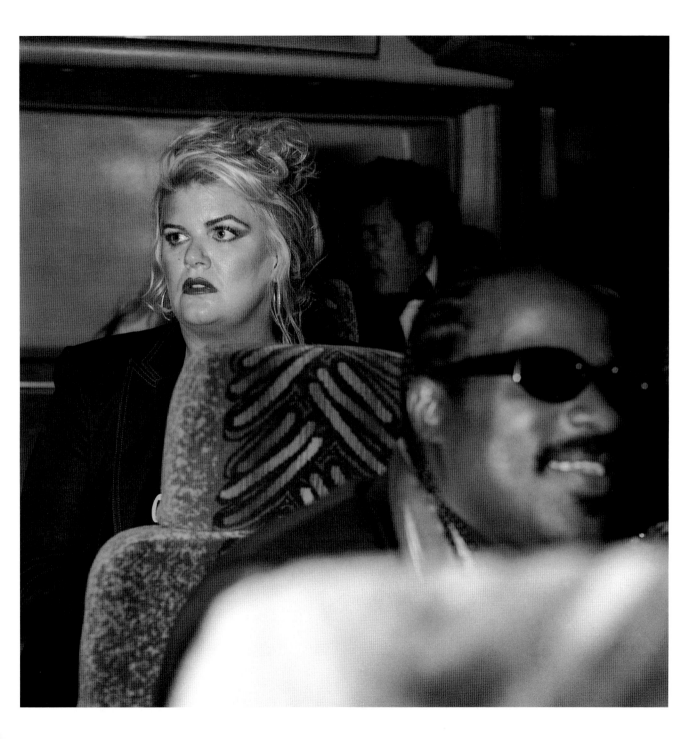

"I don't get the whole Anna Nicole Smith thing at all because James Brown died at [around] the same time.... One of the greatest musicians of all time is dead, and he gets an hour and a half worth of news. Anna Nicole Smith dies and we're still talking about her."

—Chris Rock, *The Larry King Show*, 2007

(James Brown died on December 25, 2006 and Anna Nicole Smith died on February 8, 2007.)

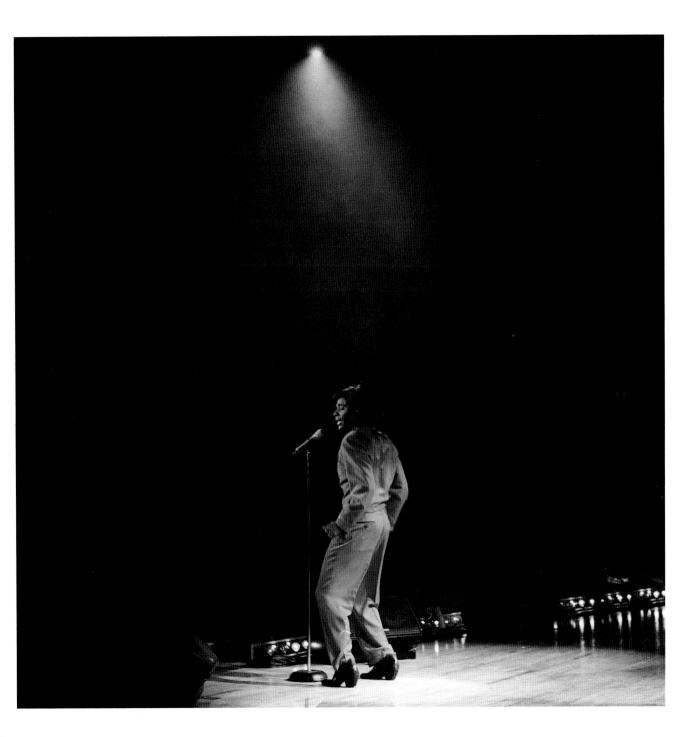

"Johnny Cash was loved, as was Elvis. Sometimes we never miss the water till the well runs dry. I think everyone, including myself, thought that Johnny was a man's man. He told it the way it was, and I guess a lot of folks would like to be able to shoot from the hip like he did. I do not impersonate The Man In Black, I pay tribute to him, which is easier for me as my bass baritone voice suits his style. It really makes me feel good when people thank me for keeping Johnny's memory alive.

"There will never be another Man in Black. Guys like him and Elvis and Roy Orbison will be with us for eternity, thanks to the folks who continue to play their music and the tribute artists who keep their image alive by performing around the world. When audiences watch their shows, they feel, just for a moment, that perhaps they are seeing and listening to the real thing. That is why I love to perform as The Man in Black."

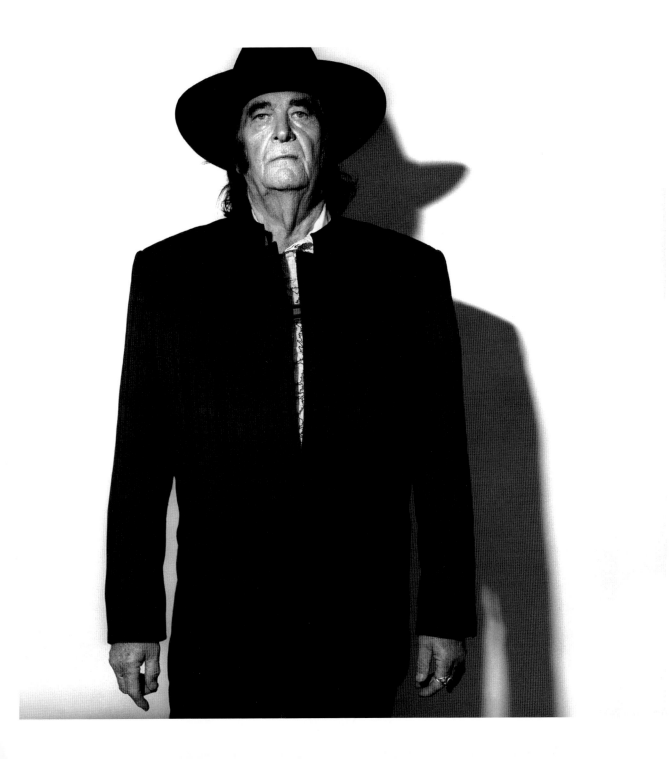

Roy met the real Willie Nelson in June 2000 when Roy was retiring and his company sponsored him to play golf in the Willie Nelson Benefit Golf Tournament in Austin, Texas.

"Some managers bought me a set of Callaway golf clubs and a bag with my nickname, Almost Willie, printed on it, and I went down to Austin. I knew people at the golf club through my business, so I asked them if I could meet Willie. A man I knew took a picture of me to Willie and told him that I would like to meet him, and Willie said, 'Bring 'im on.'

"We got pictures taken of us together. I told him, 'I hope you don't mind me impersonating you.' He said, 'Man, that's the highest form of flattery.' And I said, 'Well man, I'll tell you one thing, I'll never embarrass you.' And he said, 'I hope you have as much fun being me as I do.'"

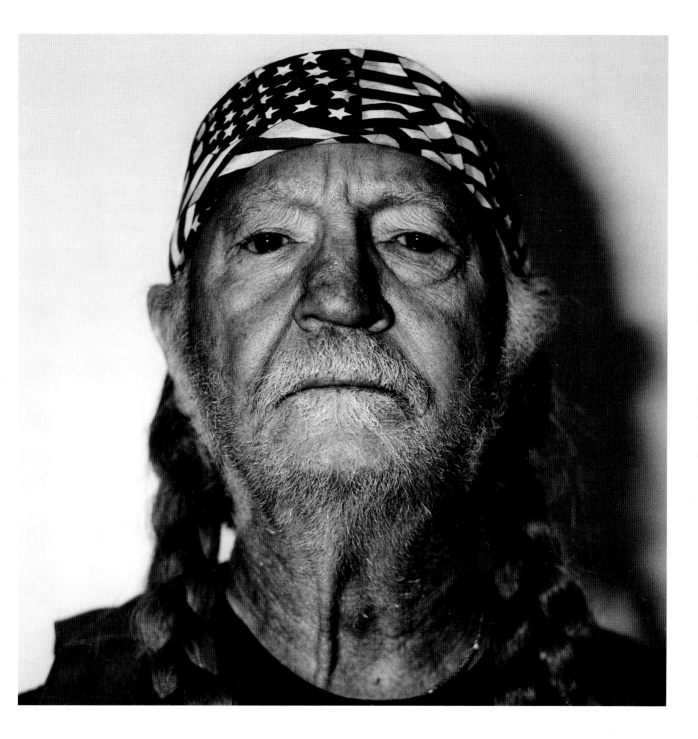

Carlene Mitchell (right) has been a successful musician for twenty years. She also performs tributes to Whitney Houston, Aretha Franklin, and Diana Ross.

"I love doing Whitney. When I was younger and she was just starting out, I thought she was incredible and looked up to her as an inspiration. She has made some bad choices, and it's tough to have seen her go down like that. I like to perform as her in her prime. That's the picture of her that I keep in my mind."

At the 2007 Sunburst Convention, Mitchell performed a *Dreamgirls* tribute along with Amber Jacks (left) and Jacquelyn Graham (center).

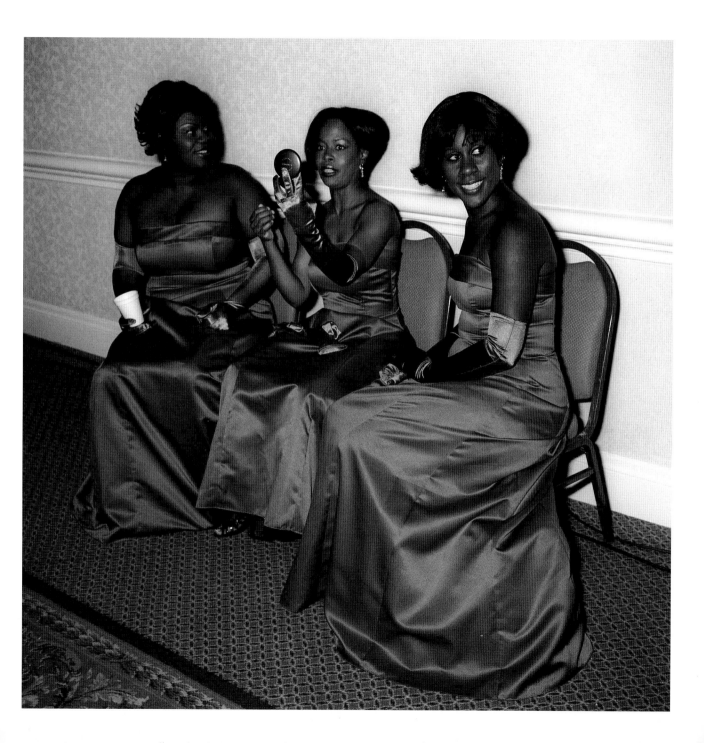

Steve Stone turned to music at an early age, taking solace in the guitar after his mother died. He says he has this in common with Paul McCartney, who also lost his mother at a young age. Steve played with a gospel band for a number of years, and during his pursuit of music, people always told him that he looks like McCartney.

"One night I got a call from a guy named John Staples. He was arguably the most dead-on John Lennon impersonator in the business. He asked if I would become his partner in a Lennon-McCartney tribute act."

The two performed together for three years until, in a tragic coincidence, John Staples, like the real John Lennon, suffered an untimely death. Steve considered retiring until he went to see Paul McCartney in concert; he was so moved by it that he decided he would continue to pay tribute to the former Beatle.

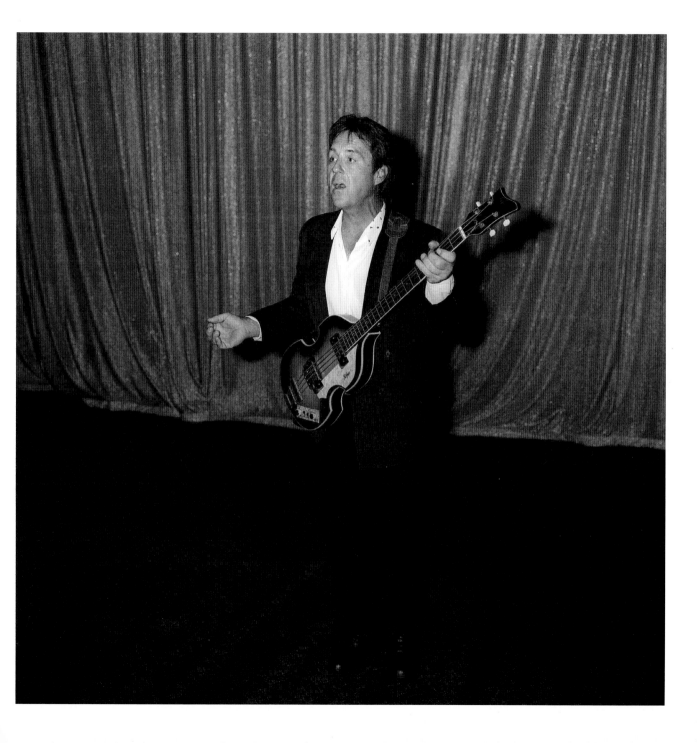

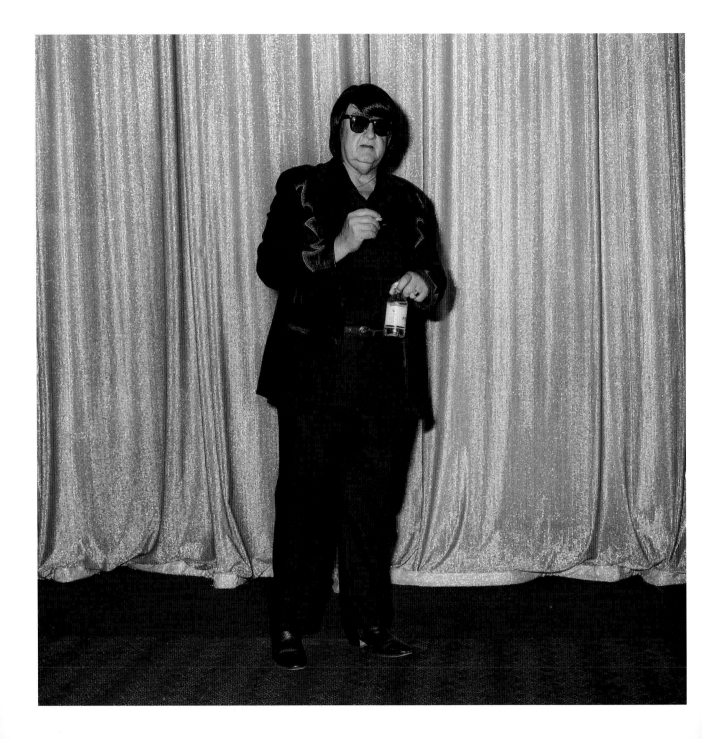

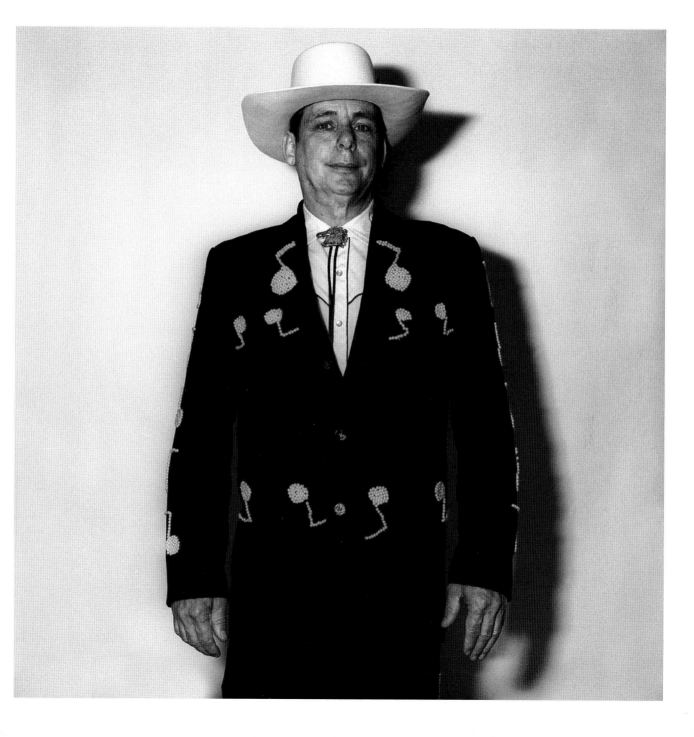

(Tina on left)

"When I was at a house party in 1984, an older gentleman came up to me and told me that I danced like Tina Turner, but I didn't know who Tina Turner was. Once I knew who she was, I could really relate to her, especially her energy. I also learned we shared some similarities: our birthdays are ten days apart. She believes she is the reincarnation of an Egyptian queen; my roots are in the Middle East. We both have masculine personalities. She's five-foot-four; I'm five-foot-two.

"I started this show because I didn't want to have any regrets when I was eighty years old. Now, performing comes naturally. It's effortless to me. There's nobody else that I could do—I'm in it for the love of her. I don't naturally resemble Tina Turner; I just want to pay tribute to her."

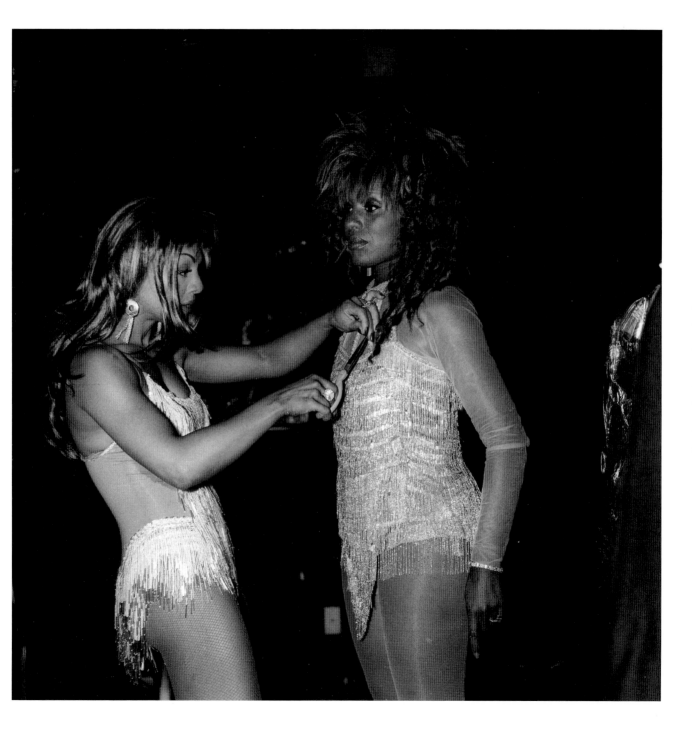

Darrell Cole used to work as a tour bus driver in Philadelphia. He started singing on the tours and before he knew it, people were lining up to ride on his bus. "It was then that I decided that I was going to have my own show.

"When I was a young child, we played Nat King Cole's music every day in our house. His music digs so deep into people. When I'm performing, I go through the crowds, interacting with people. I talk during some of the songs, and I will have to hold some people's hands because they lose it, they break down and cry. Others have a bit too much to drink and try to tear my clothes off. I have to remind them that it's not an Elvis concert. People literally fall to pieces when they hear Nat. A lot of fans love what this guy did and they say he never got the credit that he deserved. I feel it, I know it, because I see it."

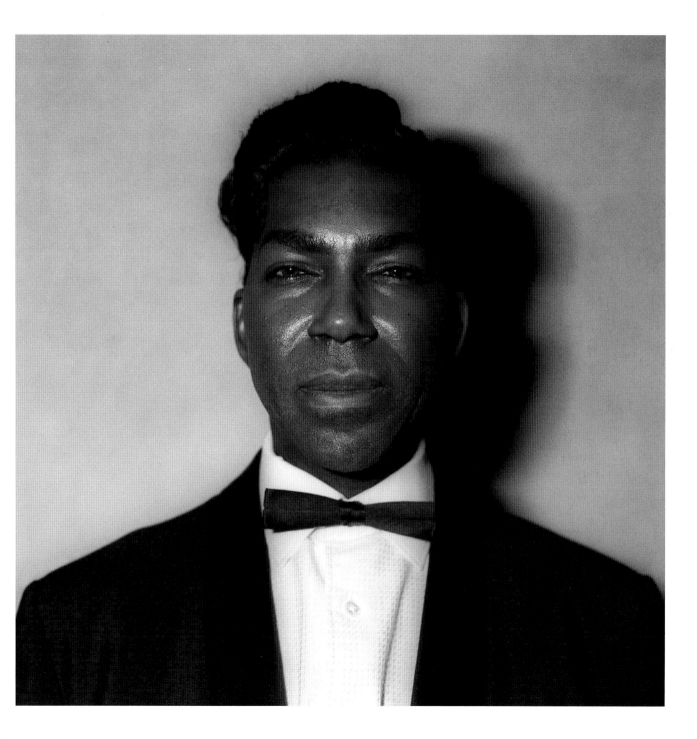

Jennifer Ramsey has a great wig collection. Like many full-time tribute artists, she portrays a variety of characters, including Marilyn Monroe, Gloria Swanson, Lucille Ball, Liza Minnelli, and as seen here, Bette Davis.

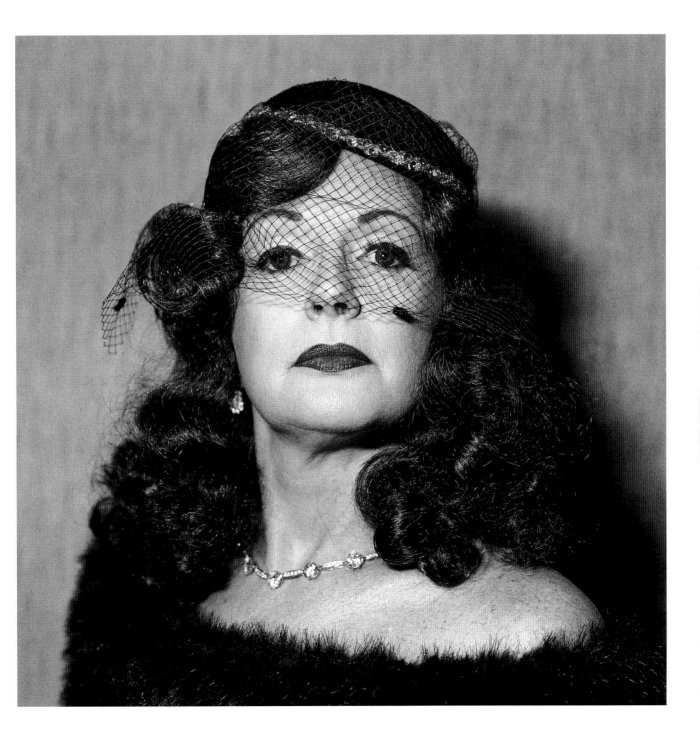

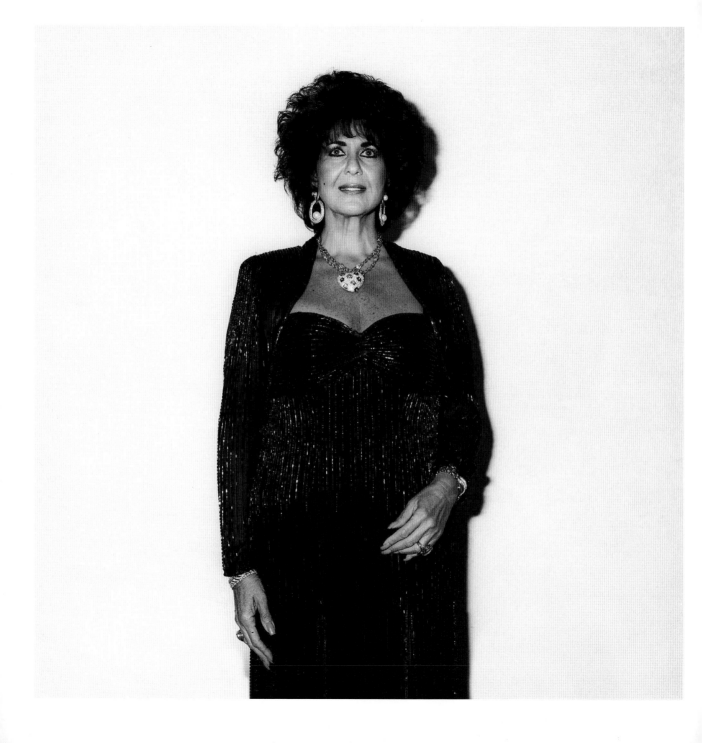

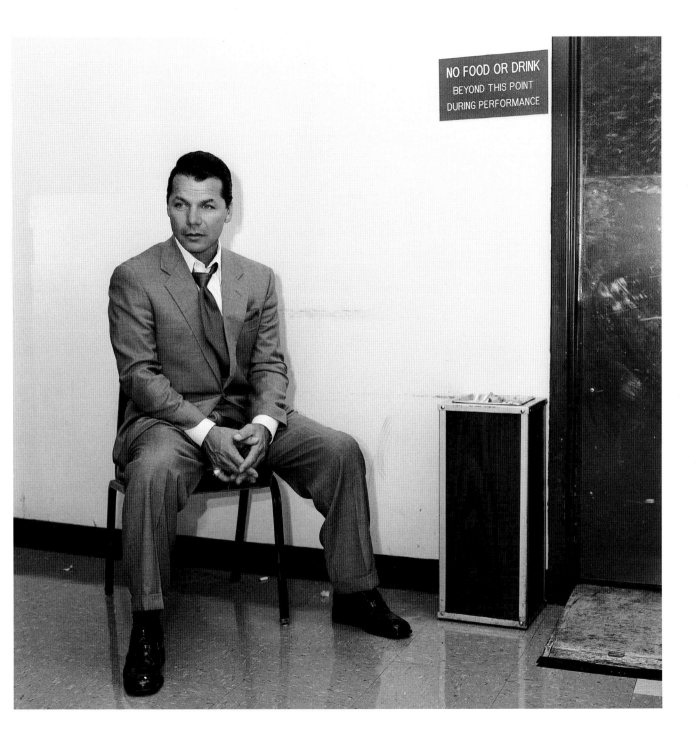

"I've been doing Sammy Davis Jr for about a year. It all started when I was singing Brooks and Dunn at a karaoke bar in Laughlin, Nevada; I'm up on the stage and pouring my heart out, and the judges said, 'Damn. What in the hell is Sammy Davis Jr doing onstage singing country music?' That kind of broke my heart.

"Then as I was driving from Laughlin to Las Vegas, I noticed all the billboards advertising the Rat Pack shows. All my life, people have been saying that I look like Sammy. I thought to myself, I love singing and dancing and all that. And that's when it clicked: do Sammy.

"All of my clothing is vintage. Recently, I was in a store and I saw this jacket. It looked cool. I picked it up and read the label, it said 'Sammy Davis Jr original.' I bought that jacket. And I still wonder, did Sammy wear this jacket? It fits me to a T.

"Before [I became an impersonator], I was trying to find my own identity and used to get upset when people told me I looked like Sammy, but now it's an honor for me to do it because I'm realizing how great he really was."

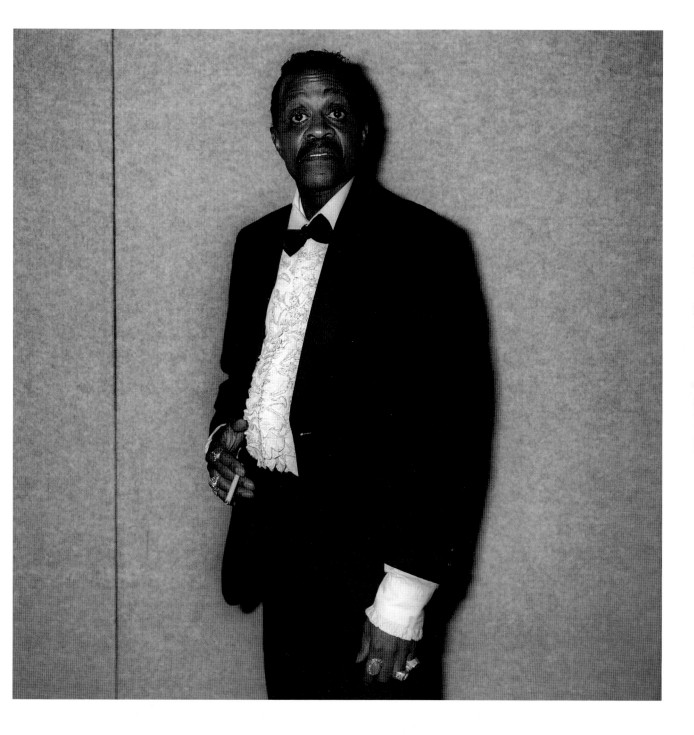

When I met Susan Rogers, she was looking at a crudely printed photo of Connie Francis and getting ready to perform. Her teenaged son and daughter were with her; both of them are impersonators too. Her daughter does Brenda Lee and Shania Twain, while her son does Ricky Nelson and Elvis.

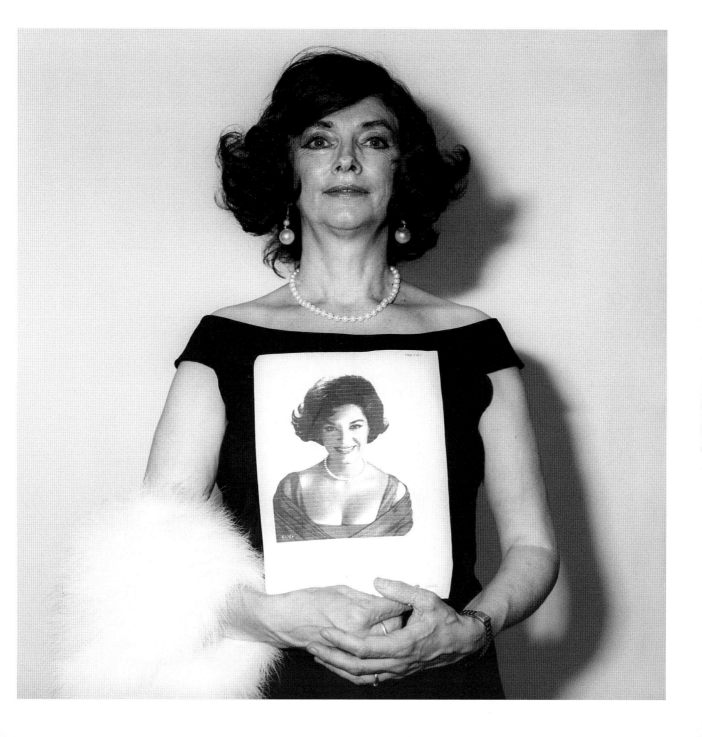

"Every time I put on the tux, it's overwhelming how people line up for pictures with me, telling stories about what he meant to them, or how they cried when he died."

Michael Coldiron's life changed the day he shaved off his beard that had turned white. As he stood before his bathroom mirror, he saw Dean Martin's face appear. Soon, like many look-alikes, he was told he looked like the legendary star everywhere he went.

One time, Michael was in Las Vegas to attend a celebrity impersonators convention. His appearance was well-received, but it was the cab ride back to the airport that he remembers most. The cabbie couldn't get over Michael's resemblance to Dean Martin and insisted that they turn around and head to the Greek Isles Hotel, where the Rat Pack tribute show was rehearsing. After auditioning, he didn't get on the show, but that experience influenced him to move from Baltimore to Vegas, where he continues to develop his 'Dino' character.

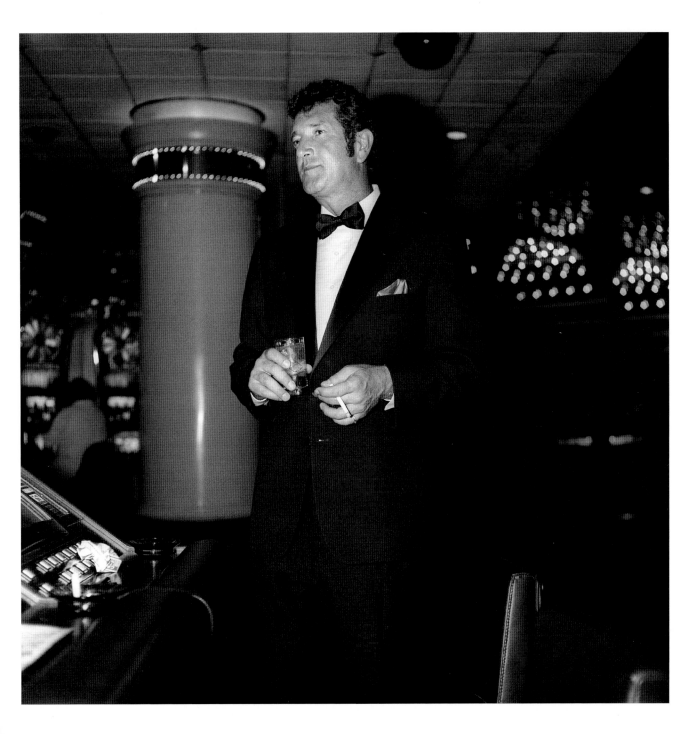

The first time I saw Sy he was dancing and singing on the stage of the Imperial Palace Theatre. He *was* Michael Jackson. He moved like him, looked like him, and had the explosive energy that Jackson exuded in his prime.

Sy was so convincing, in fact, that Jackson's own mother once told him that he was exactly like her son.

His career was filled with similar highs and lows of Jackson's, especially as Jackson's own career began to flounder due to his legal troubles; Sy would get booked for a show then have it suddenly cancelled, and as Jackson's popularity waned, Sy had trouble finding work.

Sadly, Sy died shortly after this picture was taken.

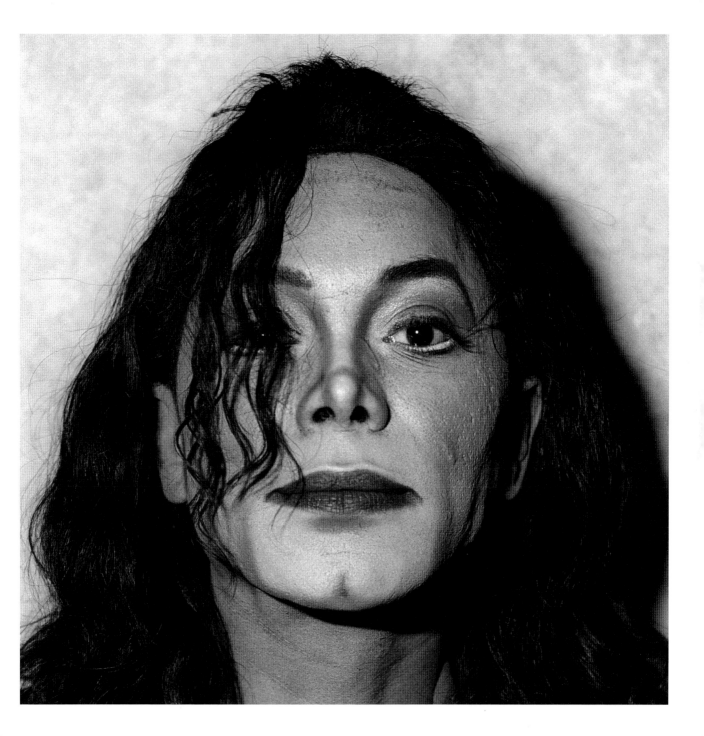

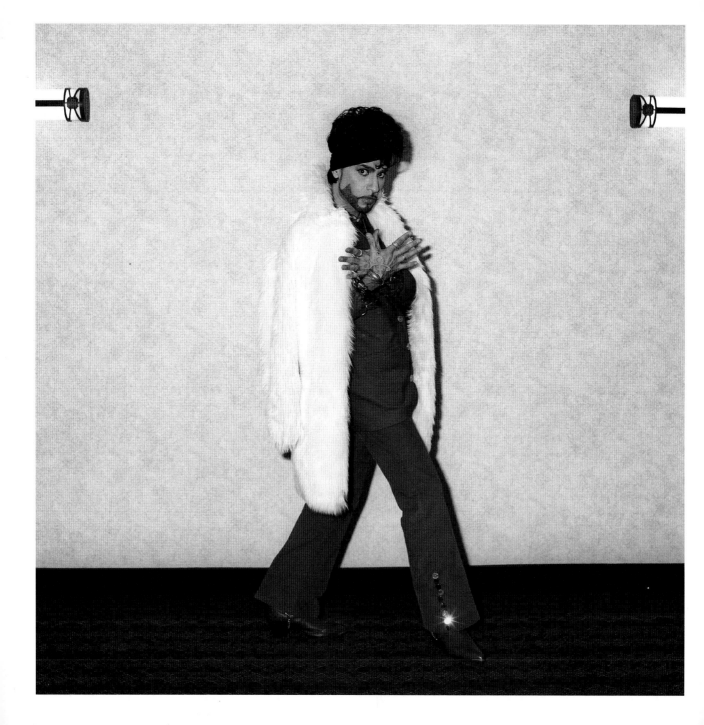

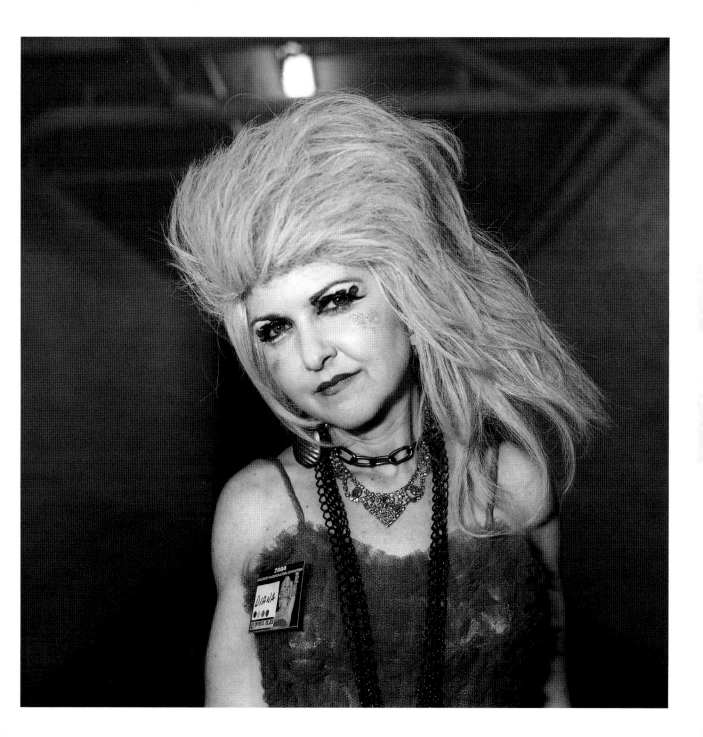

"There's a certain thing that comes to mind when you tell people that you are an impersonator. Most often they see it as a joke, until they see one performing live. There are a lot of impersonators and the ones who achieve greatness are very few; there is just a handful who are exceptionally talented.

"In 1983, I began working with Las Vegas-based, Legends in Concert as Buddy Holly. In the 1990s, I added Mick Jagger while working cruise ships. And four years ago, I started doing Ed Sullivan to fill in for another Ed Sullivan tribute artist.

"People identify with Ed Sullivan. He had every celebrity on his TV show. He's been dead for over thirty years, yet people still remember him. Everybody remembers that first Beatles performance on his show. I was four years old when it aired, and it made such an impact on me that I decided to go into music as a child. I currently play John Lennon, and perform with a Beatles group at Disney World."

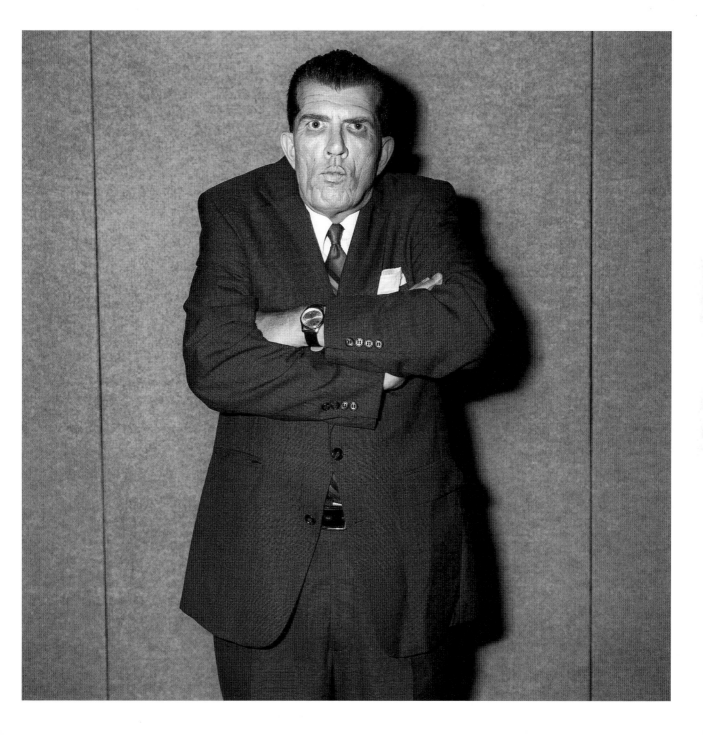

"I have retired [from being Conan O'Brien's impersonator]. I don't want to be famous anymore. I am/was the world's most famous celebrity look-alike. I created a character, Clonan, and in three years, I was in a dozen television appearances, including three on *Saturday Night Live* (never before had any celebrity look-alikes been on *SNL*.) My press kit is massive: *Village Voice, Esquire, New York Post*, etc. *Theater Scene* magazine wrote a review of my show and labeled me 'The World's Most Famous Celebrity Look-alike.' After that, *The Next Big Thing* tried to recruit me for their crappy TV show. (Imagine me actually stooping that low, that I would go on a reality TV show and let some mean, hack comedian judge me. Yeah, right.) My skin is not thick enough to be famous. I hate looking like someone famous; I wouldn't wish this on anybody. I would do anything to have my life of anonymity back."

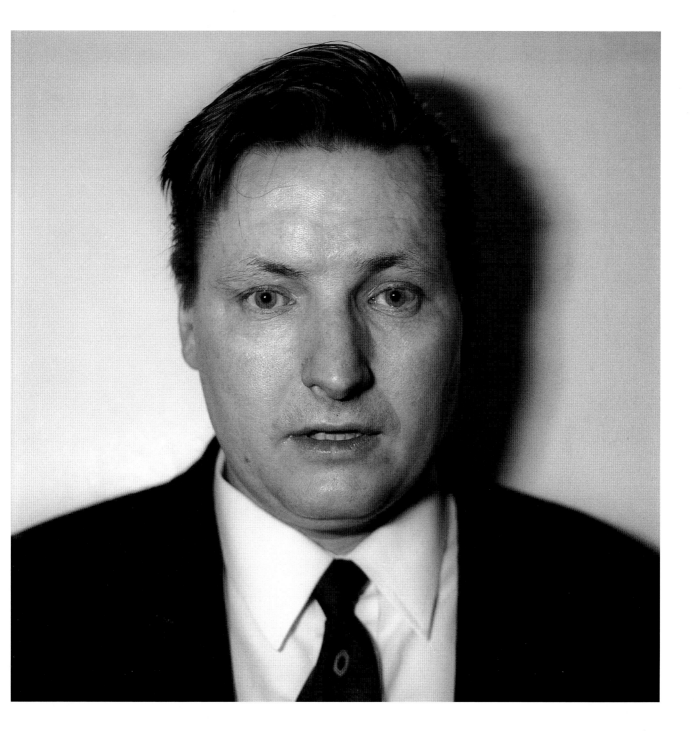

"Our responsibility as impersonators is to present the person in the best possible light, whether we're on or off the stage. Once we're in makeup and character, we owe it to that person to conduct ourselves in a professional manner. My job is to keep the Jay Leno character the way that he would like it and not bring shame upon him. Happy, congenial, nice to everyone, which is the way Jay is and the way I am."

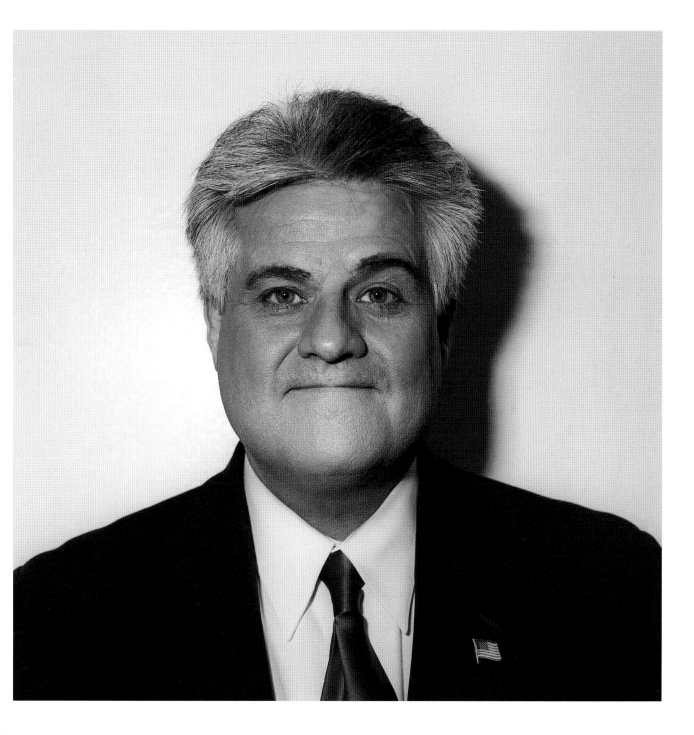

"What fascinates me about Oprah is that she is so giving and sharing. She has a good heart and the type of image that all Americans can respond to. She tries to welcome everybody and generates excitement through her powerful energy.

"Meeting Gayle King [editor of *O Magazine* and Oprah's best friend] was just as good as meeting Oprah herself. Gayle said to me, 'You look like her. I really like your hair. I always tell Oprah that I like her with the big, curly locks.'"

Each year, the Reel Awards are presented to the best celebrity impersonators in the industry. In 2007, the awards ceremony took place in Las Vegas for the first time. The categories ranged from Best Actor to Best Television Performer. The Humanitarian and the Comedy awards were both won by David Born as Robin Williams, who is seen here at the press event, where the impersonators line up in a hallway outside the ballroom, waiting to be interviewed by the media.

Celebrities may age, but their impersonators will always look exactly as they did when they were in their prime. For Steve, who has been impersonating Michael "Kramer" Richards for ten years, he thinks he looks more like Kramer today than the actor who played him on *Seinfeld* in the 1990s. As for Richards' notorious 2006 outburst in a comedy club, Steve says that the biggest shame is that the comedian made people laugh for years, but now they are going to remember him only for a few minutes of grainy video. Steve is still doing Kramer; however, he confesses that he's not as popular as he used to be.

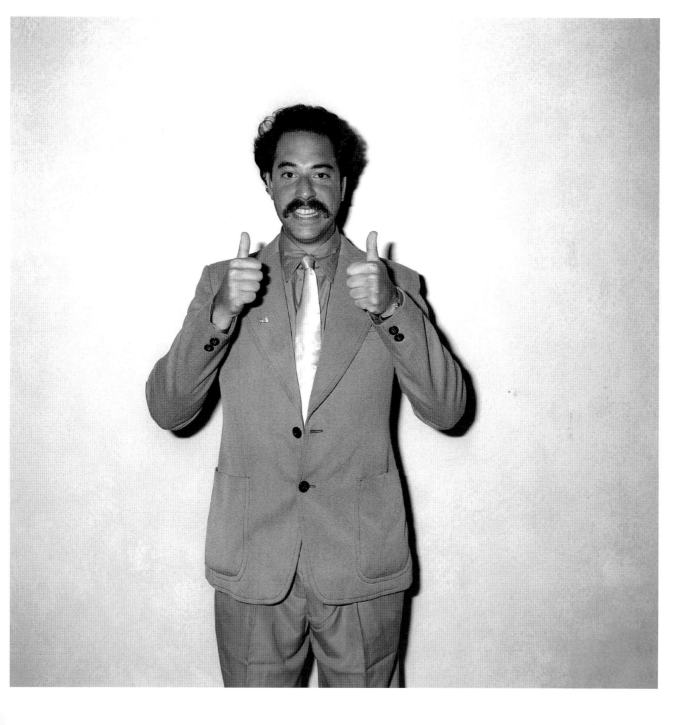

When Anne first began impersonating Roseanne, she discovered another aspect of herself. "I didn't know that I was a closet comic. But my life as an impersonator is far removed from my everyday life as a working mother. It's like stepping in and out of another world and getting paid to play dress-up."

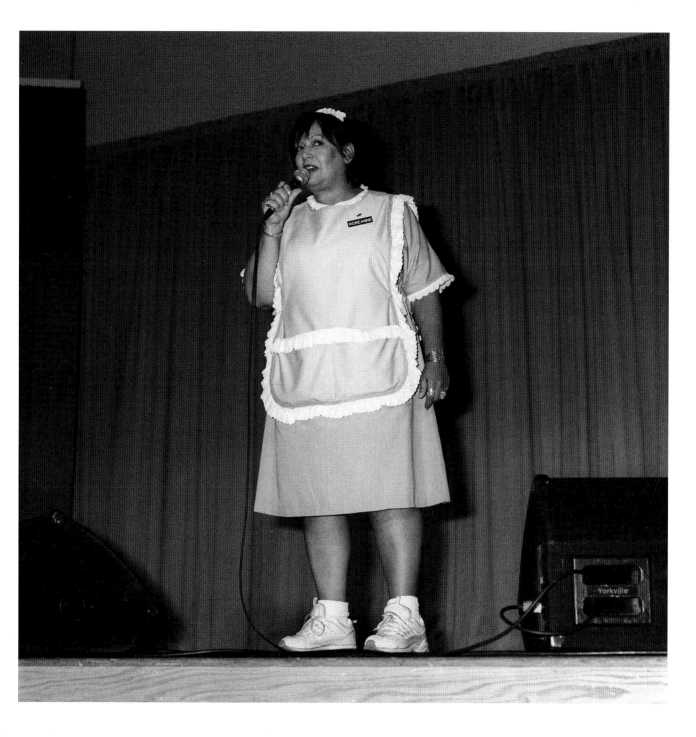

"In 1995, people started telling me I looked like 'that comedian with the buzz cut and black glasses.' They told me that I even walk and have the same body language as Drew Carey. Friends later convinced me to enter a local radio station's look-alike contest. I didn't win, but I met a comedy booker who got me my first paid job as an impersonator. I really like Drew's comedy; I love his TV shows. It's great to get paid for impersonating someone you like."

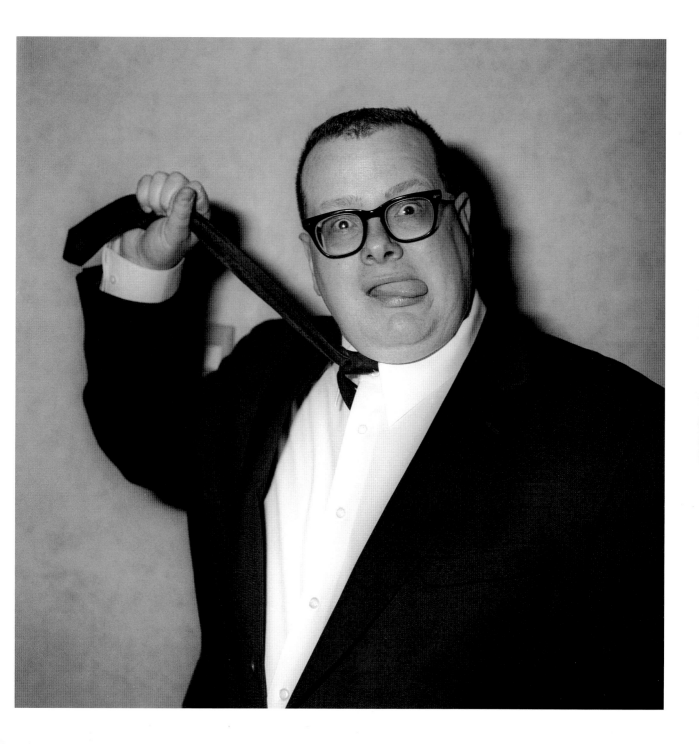

"I started out in acting doing Broadway shows. I eventually moved to LA where I was on the soap opera *General Hospital* for three years. To get on that show, I beat out forty other women to play an intensive care nurse just to say lines like, 'Should I order more plasma?' It was ridiculous. I was so bored and I needed more work.

"I have to thank Joan Rivers for giving me a life. So many people told me that I looked like her, and that I should be doing her. I said that I didn't do anybody else, I just wanted to be me. But when I eventually started impersonating Joan, it opened up a whole new world of comedy for me. I am grateful to her for so much, and for opening doors for me.

"I was born with the same face as hers, this long thin face. We also have the same kind of energy, especially with an audience. And we're both Jewish. She's a survivor. Just like me. That says it all."

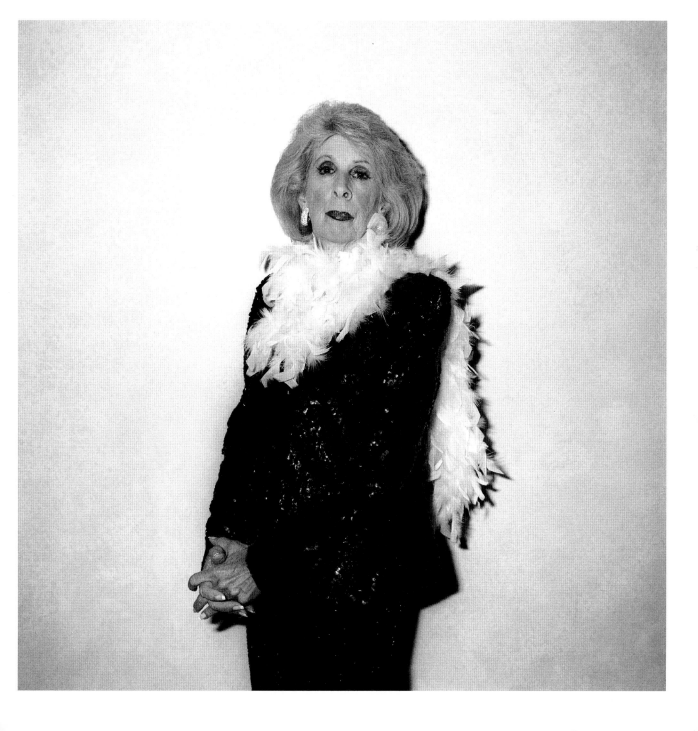

"When I get on stage, it's tough for me because I don't think of myself as an imper-sonator. I'm just being me. But all the audience sees is Rodney Dangerfield."

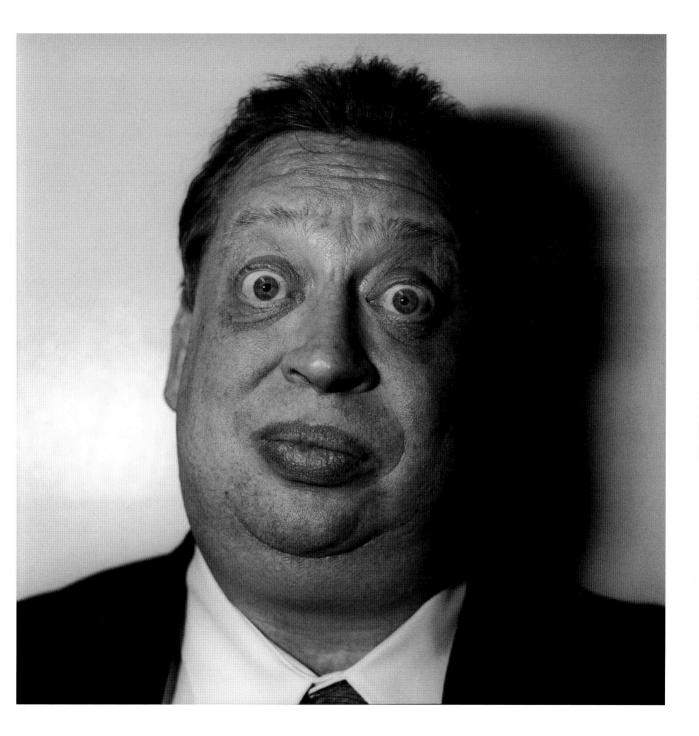

The character "Felvis" came about during Eileen's thirty-ninth birthday party, which she held at the Liberace Museum in Las Vegas while attending a convention for her jewelry business. It was there that she performed for her guests as Marilyn Monroe, Tina Turner, and Elvis.

"The thing that makes Felvis so special is she inspires and empowers women. She's about having a good time, being passionate and open-minded. Women see me perform and they say, 'She's got guts, she looks good, she's funny, *and* she can sing.'"

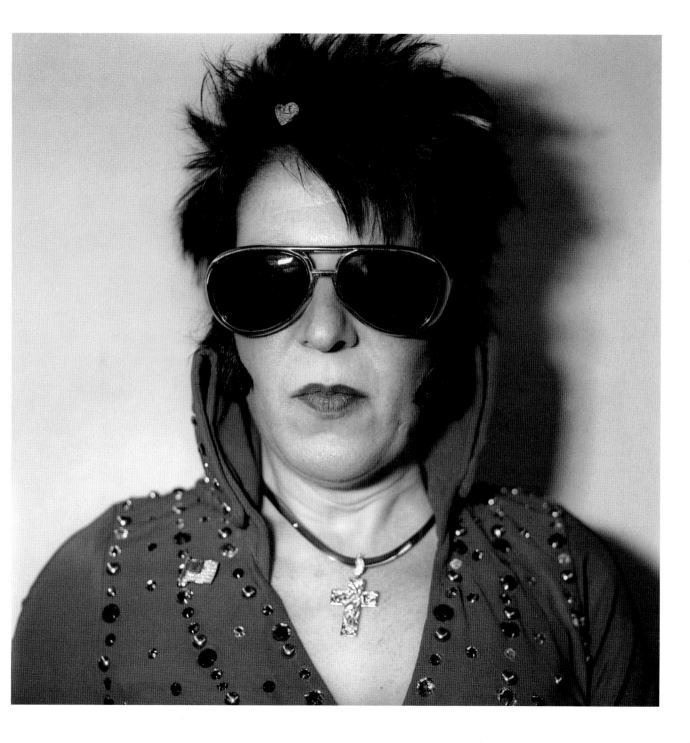

"I love impersonating Cher. I love re-creating her essence. She's bold and beautiful. I feel closest to her spirit when I'm performing and consider it a privilege to have the physicality and personality to pull her off.

"I've met Cher several times, but never while dressed as her. I first met her on my sixteenth birthday. My aunt was a designer and a friend of Cher's, and I got to go backstage to meet her after her show. Then we met again at a book signing twenty years later. After she signed her book for me, she signed a picture of me as Cher in my own book, *Double Take* [on celebrity makeovers]. I was thrilled by that.

"I have also met people who, for a moment, think I'm her; I feel honored by that. I sing live, and have worked for years perfecting Cher's voice and spirit. I feel that people really enjoy my shows, and I love to perform, so it's kind of love all around."

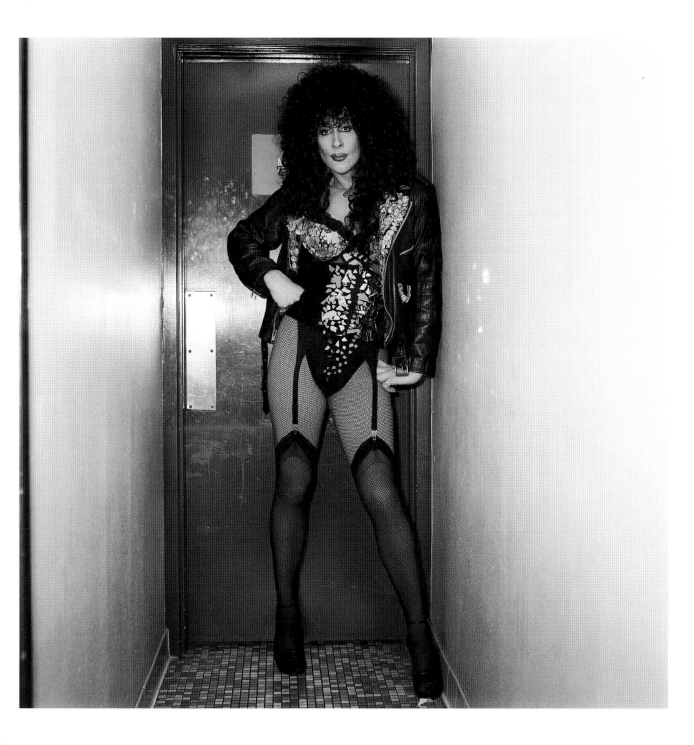

"While I was in a hotel lobby waiting for a limousine to pick me up, some people approached me and asked me if I was Cher. I told them that I was an impersonator going to an event. Soon after, I could hear them across the lobby debating about whether or not I was really Cher. When the limo arrived, they all rushed toward me and screamed, 'We love you Cher!' Then they started to sing the chorus to 'Believe.'"

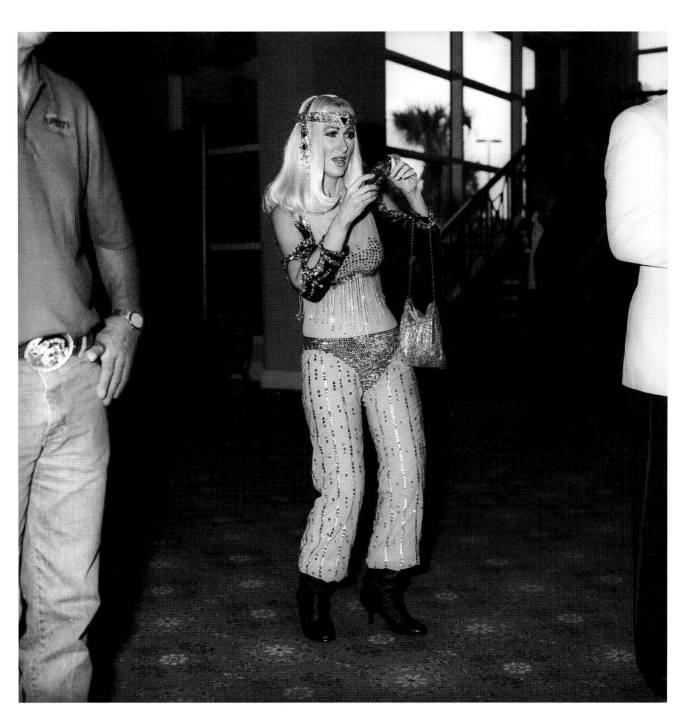

At a typical impersonator convention, following an afternoon talent showcase, the "stars" are greeted by fans—not necessarily their own fans, but fans of the character they portray. These "fans" are genuinely moved by the experience of meeting someone who looks famous, and often greet the impersonators by their character's name. The impersonators recite movie lines or assume familiar poses as cameras flash; they do their best to do their character justice. Some fans wonder if they are seeing the real thing: is that really George W. Bush, Hillary Clinton, and Cyndi Lauper hanging out in the lobby of the Imperial Palace Hotel?

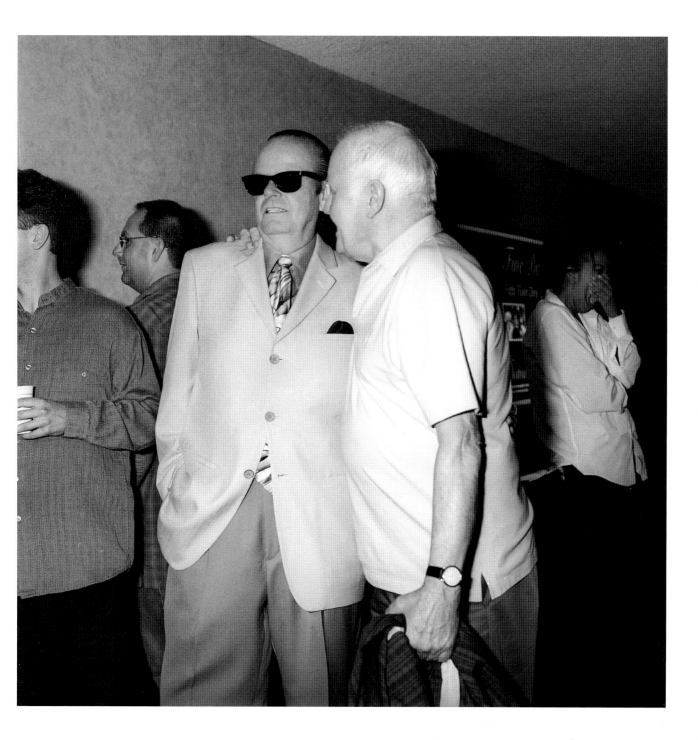

"I was impersonating Marilyn for a few years when my husband Rock got the idea that he, too, could impersonate someone: his childhood inspiration, Alice Cooper. The funny thing is, to impersonate Alice Cooper, he wears higher heels and more makeup than I do."

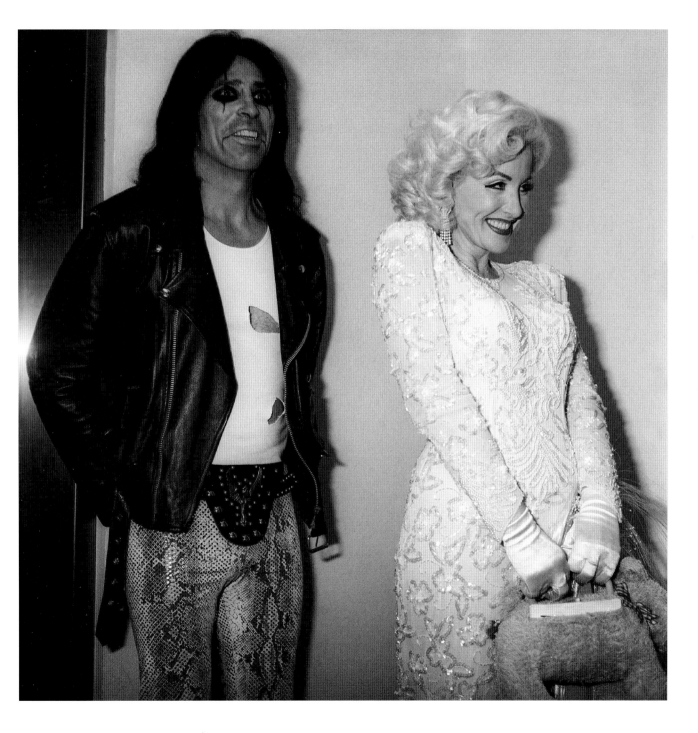

Lyndall Grant (Arnold Schwarzenegger) and Dianna Paige (Shania Twain) met at the 2003 Celebrity Impersonators Convention in Las Vegas. They got married during the following year's convention, in the wedding chapel at The Imperial Palace. Jack Nicholson was the best man, Tina Turner was the maid of honor. And the wedding guests included George and Laura Bush.

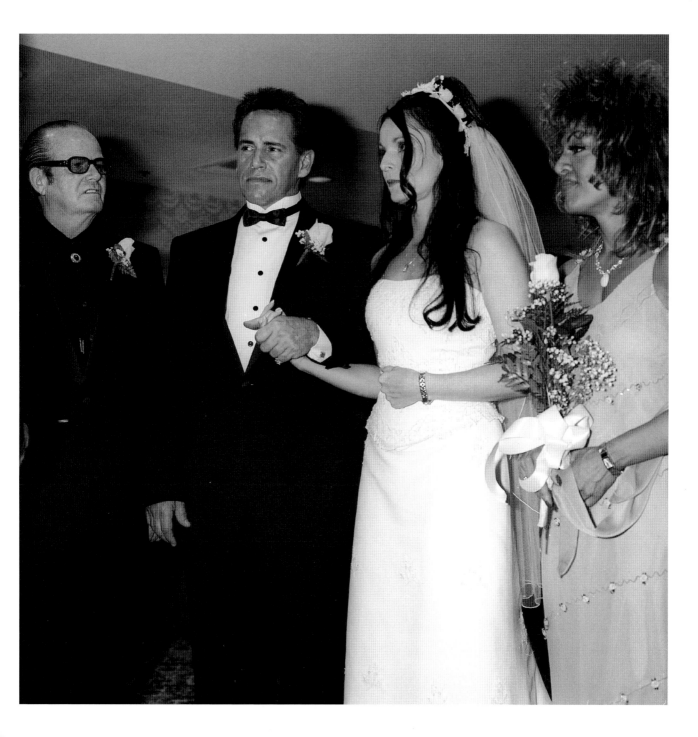

As Mike Myers, Zel attended his first Celebrity Impersonator Convention in 2006. He showed up in Las Vegas on a whim, ended up being filmed for *The Oprah Winfrey Show*, and has been working hard ever since. He takes comedy writing classes and continues to develop a number of the characters created by Myers. In particular, he's very proud of his Dr Evil, who comes onstage complete with a Mini-Me doll.

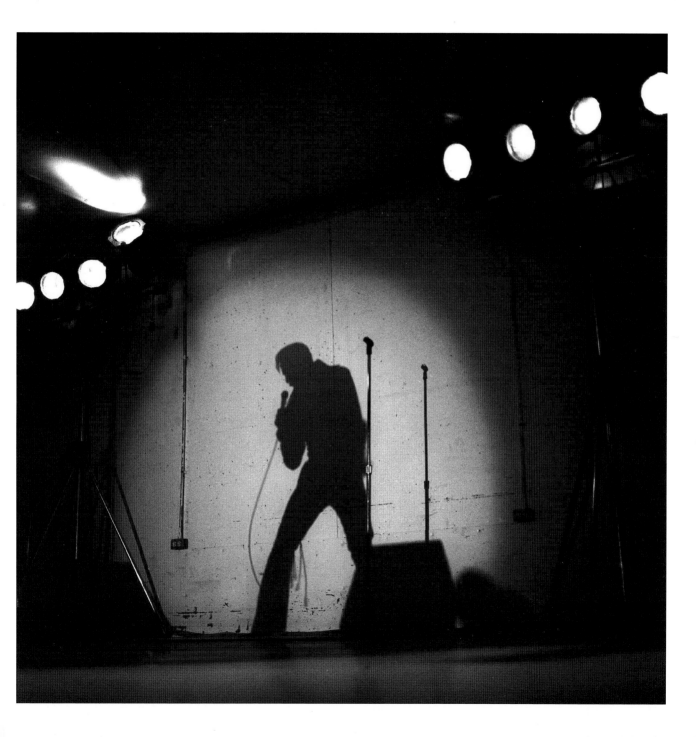

## CREDITS

Johnny Loos as Elvis Presley, page 24
Janet Valentine as Marilyn Monroe, page 33
Chris America as Madonna, page 35
Joseph Manuella as Robert De Niro, page 37
Danny Lopez as Johnny Depp, page 39
Natalie Reid as Paris Hilton, page 41
Richard De Fonzo as Liza Minnelli, page 43
Robert Ensler as Donald Trump, page 45
Steve Stone and Agadir as Mick Jagger, page 47
Jack English as Jack Nicholson, page 49
Tiffany Claus as Angelina Jolie, page 51
Renee Wiggins as Jennifer Aniston, page 53
Mark Myers as Steve McQueen, page 55
Jeff Jones as Richard Gere, page 57
Pavel Sfera as Bono, page 59
John Morgan as George W. Bush, page 61
Lyndall Grant as Arnold Schwarzenegger, page 63
Lee Lorenz as George W. Bush, page 65
John Morgan as George W. Bush, page 66
Brent Mendenhall as George W. Bush, page 67
Jerry Haleva as Saddam Hussein, page 69
Dale Leigh as Bill Clinton and Brad Bennett as Hulk Hogan, page 71
Marianne Fraulo as Hillary Clinton, page 73
Miguel Molonado as Colin Powell, page 75
Colonel Bob Thompson as Colonel Sanders, page 77

## ACKNOWLEDGMENTS

Thank you to all the tribute artists and look-alikes who made this book possible—you welcomed me into your community from day one, and I'm grateful. Special thanks to Elyse Del Francia-Goodwin and her sisters who were so helpful to me at the conventions in Las Vegas (and for pointing out that the Oprah who was there was the *real* Oprah). Also thanks to Gregory Thompson, for his assistance at the Sunburst Convention in Florida. Thank you to Norbert Ruebsaat and Stephen Osborne for your essays, and to Stephen as well for the ongoing support from *Geist* magazine, of which he is Editor-in-Chief.

I couldn't have completed this project without the love, support, and strength of my wife, Kate Marshall. You are incredible. I love you. Also I am grateful to my mother, Kay Mcdonald, who helped with the kids while I was away on assignment; to Mike Howell, who helped me compile and edit the interviews; and to Annastacia and the rest of the Mcdonald Family.

Thanks also to Jennifer Marshall for being so supportive of all my work; the Marshall family; David Campion for all those talks; Paul Wong for being Paul Wong; John Solowski, for all those quotes, the rocks, and the one thousand greys; and George Pimentel, Steve Simon, David Weir, Chuck Russell, John Donoghue, Christopher Morris, Brad Cran, Mary Janeway, Sandra Sheilds, Tanja Rohweder, Elaine Briere, Rick Collins, Sara Race, Carmine Marinelli, Evan Seal, Chris Campbell, Sharon Doucette, Per Billgren, Siri Kaur, Mary Ellen Mark, Siobahn Wiggans, Eileen Yaghoobian, Lesley Sparks, Tera Zeigler, John Chong, Dr Marty Goldstein, Cory Anderson, Elspeth Sage, Janna Joos, Len Rosenberg, Kevin Hoch, David Nations, Randall Watson, Gary Ross and everyone at *Vancouver Magazine*, Andrew

Tolson, *Maclean's* magazine, and Tom Zillich and the gang at *The Now* newspaper in Surrey, BC

I would also like to acknowledge the assistance of Beau Photo, The Lab, Roxy Isbister, Owens Art Gallery, Sergio Patrich, Vancouver Gallery of Photography, Barry at Snap Contemporary Art, the Canadian Broadcasting Corporation, the Canada Council for the Arts, Imperial Palace Hotel and Casino, Ian at Phoenix 1 International Film Services, Derek Swaile at Hagen's Travel, and Brian Cole and his staff.

Brian Howell is a freelance photographer based in Vancouver, BC, Canada. While working for clients, he continues to pursue his own documentary projects. His first book, *One Ring Circus* (Arsenal Pulp Press, 2002), was a series of photographs and narratives on indie wrestling in Canada. He is a regular contributor to *Geist* magazine, *Maclean's*, and *Vancouver Magazine*. His photographs have been exhibited and published internationally.